Images of America
Los Angeles's Olvera Street

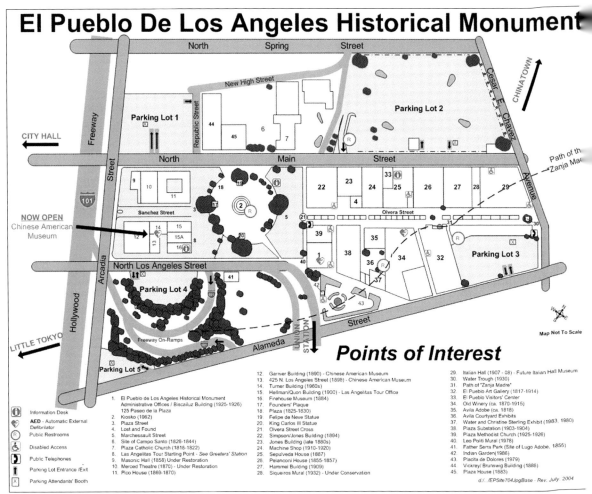

El Pueblo de Los Angeles Historical Monument, located downtown, is the birthplace of the city and home to world famous Olvera Street. The 44-acre monument is managed as a department of the City of Los Angeles. (Map by Phil Orozeo/El Pueblo de Los Angeles Historical Monument.)

ON THE COVER: Mexican entertainers pose in front of the restored Avila Adobe on Olvera Street in the 1930s. (Courtesy Bison Archives.)

IMAGES
of America
LOS ANGELES'S OLVERA STREET

William D. Estrada

Copyright © 2006 by William D. Estrada
ISBN 0-7385-3105-7

Published by Arcadia Publishing
Charleston, South Carolina

Printed in the United States of America

Library of Congress Catalog Card Number: 2005937000

For all general information contact Arcadia Publishing at:
Telephone 843-853-2070
Fax 843-853-0044
E-mail sales@arcadiapublishing.com
For customer service and orders:
Toll-Free 1-888-313-2665

Visit us on the Internet at www.arcadiapublishing.com

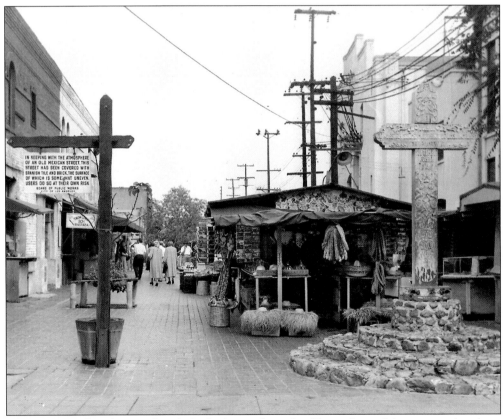

This photograph, taken in the 1940s, looks north at the Olvera Street Mexican marketplace. (Courtesy El Pueblo Historical Monument.)

CONTENTS

About the Author		6
Acknowledgments		6
Introduction		7
About El Pueblo de Los Angeles Historical Monument		8
1.	The Los Angeles Plaza and the City's First Judge	9
2.	Christine Sterling and the Birth of the Mexican Marketplace	27
3.	Olvera Street's Golden Years	51
4.	Famous Faces from Near and Far	73
5.	Olvera Street Today and Tomorrow	91
Bibliography		128

About the Author

William D. Estrada is a native of Los Angeles and curator of history at El Pueblo de Los Angeles Historical Monument. He is a social and cultural historian, and received his bachelor of arts, master of arts, and doctor of philosophy degrees in history at UCLA. He has researched and curated several exhibitions and has directed numerous public history programs that examine the rich history and diverse cultural heritage of Los Angeles, especially the experiences of the Mexican American community. From 1981 to 1989, he served as assistant dean of students at Occidental College in Los Angeles, and he has taught United States History, California History, Los Angeles History, and Chicano/a Studies at California State University, Long Beach and Northridge, East Los Angeles College, Santa Monica College, and Occidental College. He is the author of several publications; most recently are two essays in the Oxford Encyclopedia of Latinos and Latinas in the United States (2005). His forthcoming book *The Los Angeles Plaza: Sacred and Contested Space* will be published in 2007 by the University of Texas Press.

Acknowledgments

Several people and institutions generously contributed to the completion of this book. I would especially like to thank El Pueblo de Los Angeles Historical Monument for allowing me to use their unique photograph collection on Olvera Street: Rushmore D. Cervantes, Suellen Cheng, Mariann Gatto, Jean Bruce Poole, Caroline Asencio, Linda Duran, John Kopczynski, Phil Orozco, Cynthia Vallejo, Julie Sandoval, Norma Garcia, Diana Robertson, and all of the employees of El Pueblo de Los Angeles Historical Monument. Several other groups and individuals were equally supportive of this project: Las Angelitas del Pueblo, the Los Angeles Central Library, Carolyn Cole, the Huntington Library, Seaver Center for Western History Research, Los Angeles County Museum of Natural History, Bison Archives, John Bengtson, Patricia Estrada, Amelia Estrada, David Estrada, and the merchant families of Olvera Street. Special thanks must go to Don Sloper, who provided needed technical support and encouragement.

I would also like to thank Frank Damon and Ezekiel Tarango, whose wonderful photographs of "Olvera Street Today and Tomorrow" help us understand the visual beauty and rich culture of the birthplace of Los Angeles. Finally, I would like to thank the John Randolph Haynes and Dora Haynes Foundation and Historical Society of Southern California for their generous support of my ongoing research on the history of Los Angeles.

INTRODUCTION

Los Angeles is known throughout the world as the "city of dreams," the home of Hollywood movies, year-round sunshine—with an occasional earthquake—and unlimited opportunity for people who come from all corners of the world seeking a better life. The city also boasts some of the world's most famous streets, from busy Sunset, Hollywood, Vine, Wilshire's "miracle mile," and Whittier Boulevards to Rodeo Drive. But for those who truly wish to understand the cultural essence of Los Angeles, Olvera Street—a narrow 560-foot walkway in the northern section of downtown, known by Spanish speakers as *Calle Olvera*—perhaps best captures the hopes, dreams, and indomitable spirit of the City of Angels. Olvera Street is at once the historic heart of Los Angeles, popular tourist site, and Mexican American cultural symbol. The street has witnessed festive celebrations from the days of the ranchos, pitched battles between the armies of Mexico and the United States, and seen a gradual decline as the unrivaled social and cultural center of the city. Even so, the story of this little street, from the days of Pío Pico to its restoration in the 1930s by Christine Sterling, affectionately known as the "Mother of Olvera Street," is often overlooked in the growing body of books, articles, and films about Los Angeles. Whatever terms contemporary critics may use to describe the little street—"commercialized," "romanticized," or "tourist trap"—the fact remains that on no other street in Los Angeles are the layers of history and the stories of real people unveiled as they are on Olvera Street.

In commemoration of the 75th anniversary of the opening of Olvera Street as a Mexican marketplace, this book attempts to capture some of the significant chapters and personal memories in the rich history of this unique cultural landmark located at the birthplace of the city.

About El Pueblo de Los Angeles Historical Monument

El Pueblo de Los Angeles Historical Monument is near the site of the early Los Angeles pueblo where 44 settlers of Native American, African, and European heritage journeyed more than 1,000 miles across the desert from present-day northern Mexico and established a farming community in September 1781. Since that time, Los Angeles has been under the flags of Spain, Mexico, and the United States and has grown into one of the world's largest metropolitan areas. In 1953, this oldest and most historic section of the city was designated as a state historic park, reflecting the heritage of many ethnic groups—Native American, Spanish, Mexican, Anglo, African American, Chinese, Italian, and French—who contributed to the early history of the city. Today as a department of the City of Los Angeles, El Pueblo is a living museum that continues to fulfill its unique role as the historic and symbolic heart of the city.

Of the monument's 27 historic buildings, 11 are open to the public as businesses or have been restored as museums.

Tour Information:
Free educational tours of El Pueblo are conducted Tuesday through Saturday by El Pueblo's volunteer docents, Las Angelitas del Pueblo, at 10:00 a.m., 11:00 a.m., and 12:00 p.m. These tours start at the Las Angelitas del Pueblo office, located next to the Old Plaza Firehouse on the southeast end of the plaza. For tour reservations and information, call (213) 628-1274.

To Join:
Las Angelitas del Pueblo (docents):	(213) 473-5206 or www.lasangelitas.org
Friends of the Chinese American Museum:	(213) 485-8484 or www.camla.org
El Pueblo Park Association:	(213) 485-6855
Historic Italian Hall Foundation:	(323) 257-9400 or www.italianhall.org

Main Numbers:
El Pueblo Visitors Center (tour reservations)	(213) 628-1274
Las Angelitas del Pueblo (docent office)	(213) 473-5206
Chinese American Museum	(213) 485-8567
El Pueblo de Los Angeles Historical Monument Administration	(213) 485-6855

El Pueblo de Los Angeles Historic Monument
125 Paseo de La Plaza, Suite 400
Los Angeles, California 90012
(213) 628-1274
www.cityofla.org/elp/

One
THE LOS ANGELES PLAZA AND ITS FIRST JUDGE

Olvera Street is located in the oldest and most historic section of Los Angeles, in what became the El Pueblo de Los Angeles Historical Monument. When *El Pueblo de la Reina de Los Angeles* was founded on September 4, 1781, by 44 settlers from northwest Mexico, houses were built around a central plaza. The present plaza is the third, or even fourth, location of the plaza. It was laid out between 1825 and 1830. On the north side of the plaza, a short street named Wine or Vine Street ran in a north-south direction. It ended at a bluff leading down to the *Zanja Madre* (Mother Ditch), which flowed diagonally from northwest to southwest and provided precious water for the young pueblo. Houses were built on Bath Street, Vine Street, and Alameda.

Adobe houses also were built on the south and east sides of the plaza. On the west lay the church, La Iglesia de Nuestra Señora La Reina de Los Angeles, which was completed in 1822. The church was the focus of the community, and its main door marked the center of the city for the first survey map of Los Angeles, prepared in 1849 by U.S. Army lieutenant Edward O. C. Ord.

Following the United States and Mexico War and the gold rush, major changes came to the area. In the 1860s, the Mexican ranching community (rancheros) lost their wealth and property to the Americans. Major economic losses for the Californios (as the rancheros called themselves) also were caused by a severe drought, which killed thousands of head of cattle. In 1876, the Southern Pacific Railroad connected San Francisco and Los Angeles, causing a massive influx of new settlers from the east. The plaza was relandscaped in a circular design, reflecting the cultural sentiments of the emerging American city. On the south side of the old square, the Pico House Hotel and Merced Theatre were constructed in 1869–1870 and for a brief time helped to stem the movement of the civic center southwest of the plaza. Even so, a new civic center would gradually emerge near present-day Temple and Main Streets and city hall. Olvera Street was located in the center of this changing landscape.

References to Vine or Wine Street's name being changed to Olvera Street are found as early as the first Los Angeles City and County Directory, which was published in 1872. Eleven people were listed in the directory as residents of Olvera Street (sometimes misspelled "Olivera" or "Olavera"). But the street's name was not officially changed until 1877.

The street's name was changed at the urging of local citizens and by a city council ordinance in recognition of the lifetime of public service to the city and county by Agustín Olvera, the first superior court judge of the City and County of Los Angeles. Olvera once owned an adobe home on the north side of the plaza, where today's Plaza Methodist Church and Biscailuz Building are presently located. The home was originally built in 1830 by Bartolo Tapia, who was once alcalde (mayor) of Los Angeles. Tapia passed the building down to his son Tiburcio Tapia, who in turn sold it in 1856 to Judge Olvera. Don Agustín Olvera and his wife, Doña Concepción Arguello de Olvera, made their home on the plaza a center of social activity for the pueblo and a place where the judge held court proceedings. Following his death in 1876, a request was made to the city council to extend Vine or Wine Street to Macy Street (now Avenida Cesar E. Chavez) and to rename it Olvera Street. The request was unanimously approved.

After the name change, Olvera Street remained an unpaved alley and, with the plaza, continued to decline in significance. Slightly west of Olvera Street, Bath Street became an extension of Main Street in 1886. Eighteen feet were cut off from properties running along both sides of Bath Street in order to accommodate the Main Street extension. After the street widening, new buildings (some of which exist today) were constructed along Main Street and on the plaza. These buildings include the Sepúlveda House (1887), the Jones Building (late 1880s), the Simpson/Jones Building (1894), the Machine Shop building (1910–1920, and later the Gibbs Brothers Electric Building), the Italian Hall (1907–1908), and Hammel Building (1909). On the east side of Olvera Street, the Avila Adobe (1818) and the winery (1870–1915) remained in place. In 1903–1904, the Plaza Substation was erected, and the Winery building was extended in 1915. At the south end of the street facing the plaza, the Olvera Adobe stayed in place until it was razed in 1917 and replaced by the Plaza Methodist Church and Plaza Community Center (now the Biscailuz Building) in 1925–1926.

By the beginning of the 20th century, the plaza area was again transformed and was being used for light industrial use. Its gradual decline as the center of civic life began in the 1870s, leading to its reclamation by diverse sectors of the city's poor and disenfranchised, especially working class Mexican, Italian, Japanese, and Chinese immigrants. Many of the city's unemployed would gather in the plaza, which became the unrivaled center of labor and political activity—a scene that often led to violent encounters with the police. Well-known radicals and revolutionaries such as Emma Goldman, Ricardo Flores Magón, Upton Sinclair, and Dr. Sun Yat-Sen, all found supportive audiences at the old square. The plaza's once elegant buildings, such as the Pico House and Merced Theatre, were now being used for small businesses and as rooming houses for workers. The original Chinatown of Los Angeles, on the east side of the plaza where Union Station is presently located, began in 1870 and grew to over 3,000 residents by 1900. Long misunderstood, Chinatown was constantly under the critical watch of local police, the press, and social reformers who unfairly perceived the community as the primary source of urban blight.

This was the atmosphere that Christine Sterling found when she first walked through the plaza area. The city's birthplace was a vibrant immigrant community, yet many of the oldest and most historic buildings were in a state of ruin and nobody seemed to care.

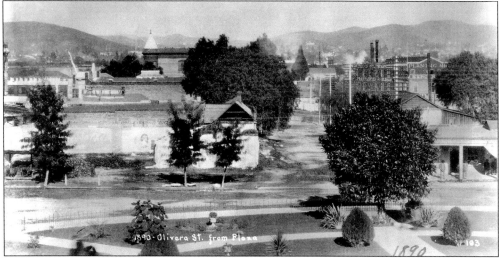

Here is Olvera Street (misspelled Olivera) looking north, in 1890. The large Moreton Bay fig tree (*Ficus macrophylla*), in the center to the right, was one of four planted around 1878. The building behind the tree is the adobe of Agustín Olvera. Today the trees still stand and continue to provide beauty and shade for Olvera Street visitors. (Courtesy Huntington Library.)

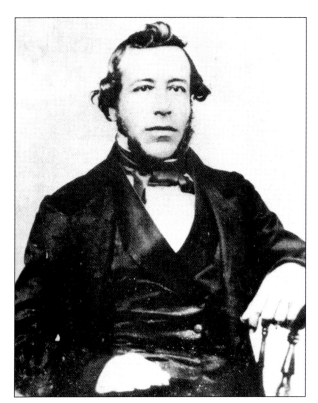

Judge Agustín Olvera (c. 1820–1876) was a Mexican settler who arrived in California as part of the unsuccessful Hijar-Padres colony, a company of Mexicans organized to settle the newly secularized California missions between 1834–1835. By 1841, he was commissioner for the secularized mission of San Juan Capistrano, where he also served as judge. He came to Los Angeles in 1845, fought against the Yankees in the U.S. and Mexico War, and was one of the signatories of the Treaty of Chauenga in January 1847. Olvera later became a farmer in Los Angeles, the first judge of Los Angeles County and City, county supervisor, and even president elector. After his death in 1876, Olvera Street was named in his honor. (Courtesy California Historical Society/TI collection.)

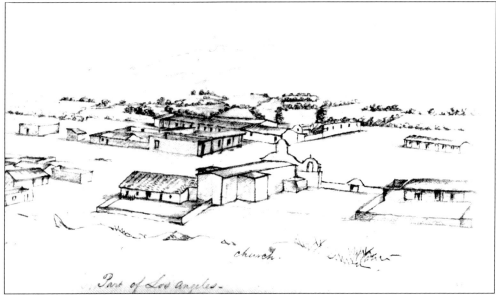

Here is an 1847 view of the pueblo of Los Angeles looking east. In the center is the Plaza Church—La Iglesia de Nuestra Señora La Reina de Los Angeles. Just above the church bell tower is the adobe of Bartolo Tapia, who once served as alcalde, or mayor, of Los Angeles. His son Tiburcio Tapia would later sell this adobe to Agustín Olvera. The street running from the corner of the adobe to the left or north of the plaza is *Calle Vino* or Wine Street. It would later be renamed for Judge Olvera. (Drawing by William Rich Hutton; courtesy Huntington Library.)

In 1856, Judge Olvera bought the adobe, pictured here in 1912, from Tiburcio Tapia. He often held court proceedings in the adobe. Over this distinguished home also presided Don Agustín's wife, Doña Concepción Arguello de Olvera, daughter of Southern California's celebrated Don Santiago Arguello, the owner of La Punta Rancho and the lands of Agua Caliente, which is the present city of Tijuana in Baja California. From the 1850s to the 1870s, the adobe was a social gathering place for Los Angeles. In 1917, the adobe was razed to make way for the future Plaza Methodist Church and Plaza Community Center (United Methodist Church Conference). Today the site is home to the Plaza Methodist Church and Biscailuz Building. (Courtesy Huntington Library.)

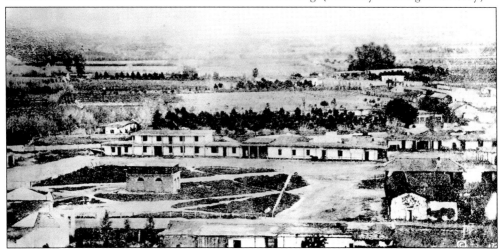

The plaza, as it appeared in 1862, is the first photograph of Los Angeles. The two-story Lugo House is fronting the plaza. At right front is the adobe built by José Antonio Carrillo and future site of the three-story Pico House. Behind the Carrillo Adobe stands the one-story adobe of Gov. Pío Pico, which served as his official office. The brick water reservoir is in the center. (Courtesy Los Angeles Public Library/El Pueblo Historical Monument.)

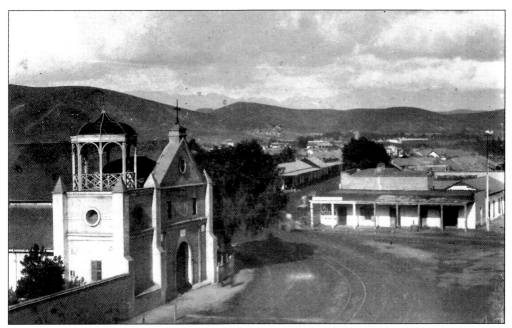

An 1873 view of Our Lady Queen of Angels Catholic Church—La Iglesia de Nuestra Señora La Reina de Los Angeles—looks north on Main Street toward present-day Chavez Ravine, the site of Dodger Stadium. Affectionately known as the Old Plaza Church, or *La Placita*, it was constructed in 1818–1822 and is the oldest house of worship in the city. Today the little church is a powerful religious and cultural symbol for the city's large Latino immigrant community. (Courtesy Huntington Library and Art Collection, San Marino, California.)

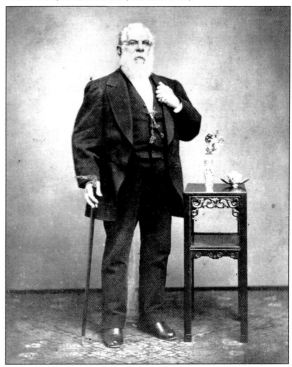

Pío de Jesús Pico (1801–1894) was the last governor of California under Mexican rule. He was born at San Gabriel Mission and helped to shape nearly a century of California history. Governor Pico owned an adobe on the south side of the plaza that also served as California's capitol building in 1845–1846. He later sold his vast landholdings in the San Fernando Valley to build the Pico House, the city's first three-story building. (Courtesy El Pueblo Historical Monument.)

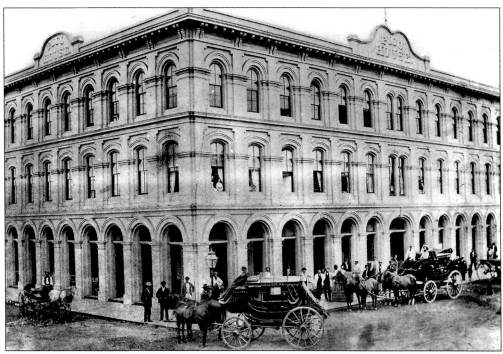

The Pico House, the first three-story building in the city, opened in 1870. During the 1870s, stagecoaches would pick up passengers at the port in San Pedro and carry them to the hotel in the heart of town. When the hotel opened in 1870, it was considered to be the finest and most elegant hotel south of San Francisco. Today the building is undergoing restoration. Since the 1980s, the first floor of the building has been used as a gallery space for exhibits and community events. (Courtesy El Pueblol Historical Monument.)

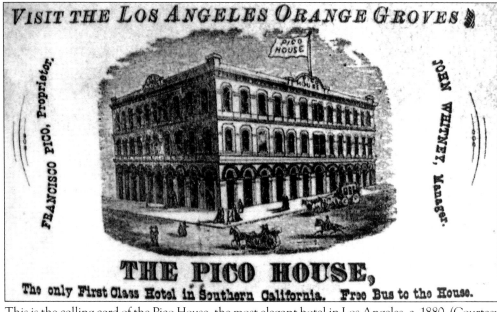

This is the calling card of the Pico House, the most elegant hotel in Los Angeles, c. 1880. (Courtesy El Pueblo Historical Monument.)

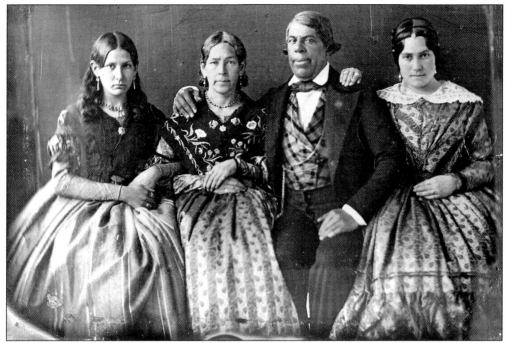

In 1852, Pío de Jesus Pico and his wife, Señora María Ignacia Alvarado Pico, are with their nieces María Anita Alvarado (left) and Trinidad Ortega (right). Today the Pico name on streets and buildings, as well as family descendants, are found throughout California. (Courtesy Seaver Center for Western History Research, Los Angeles County Museum of Natural History.)

Pío Pico's one-story adobe residence (center) is pictured here in 1895. The building also served as the capitol of Mexican California (1845–1846), after Governor Pico decided to move the capital from Monterey to Los Angeles. It was razed in 1898 and today is the site of the Hellman/Quon Building, constructed between 1899 and 1900. (Courtesy Huntington Library and Art Collection, San Marino, California.)

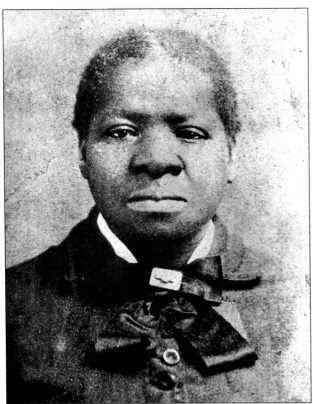

Bridget "Biddy" Mason (1818–1891) came to California as a slave. In a celebrated 1855 court case, she won her freedom for herself and her children and became a successful businesswoman, property owner, philanthropist, pioneer of the African American community of Los Angeles, and was well known for her charitable work with the city's poor. She was the first African American woman to own property in Los Angeles and during the late 19th century was a well-known and respected figure at the plaza, where she often dined at the Pico House. (Courtesy Los Angeles Public Library.)

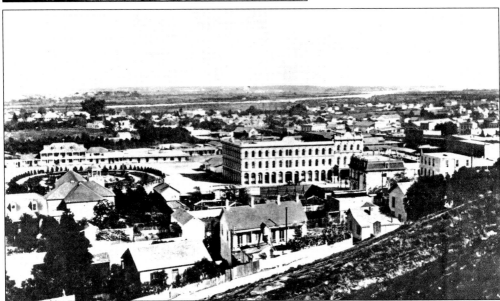

This 1876 photograph of the plaza, looking east, shows the Pico House (1870) at right, the town's most elegant hotel. The Merced Theatre (1870), the area's first performing arts house, towers over the plaza. The Plaza Catholic Church and rectory are at left, while the two-story Lugo House is now being used as a boy's school. In the distance, the Los Angeles River flows west toward the Pacific Ocean. (Courtesy El Pueblo Historical Monument.)

Señora Eloisa Martinez de Sepúlveda (1863–1903) was born in Sonora, Mexico, and came to Los Angeles when she was 11 years old. She was an independent property owner and businesswoman of the late 19th century. She owned cattle, horses, and land, and registered her own cattle brand. In 1887, she built the Sepúlveda House, a business and residential building on North Main Street. Designed in the Eastlake Victorian style, the Sepúlveda House had 22 rooms, including two large stores fronting Main Street. (Courtesy Seaver Center for Western History Research, Los Angeles County Museum of Natural History.)

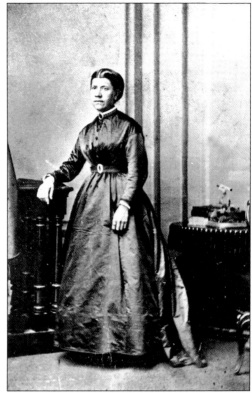

This is the Sepúlveda House as it appeared during the 1920s. Today the Sepúlveda House is home to the El Pueblo Visitors Center and is listed on the National Registrar of Historic Places.(Courtesy El Pueblo Historical Monument.)

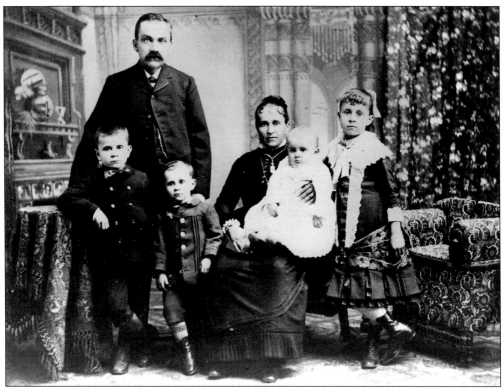

In 1830, the first French settler came to Los Angeles. From the 1860s to the turn of the century, a vibrant French community was located on the southeast side of the plaza along Los Angeles Street to Aliso Street. The French business community at the plaza included Philippe Garnier, builder of the Garnier Block, his wife, Jeannette, and their four children, c. 1890. (Courtesy El Pueblo Historical Monument.)

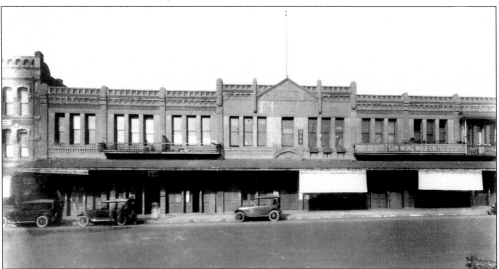

The Garnier Block (1890) on Los Angeles Street was a vital part of old Chinatown and is today home of the Chinese American Museum, where the histories of old Chinatown and today's Chinese American community are told. (Courtesy Chinese American Museum.)

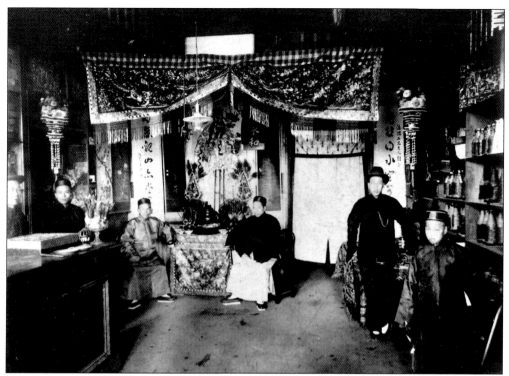
The Sun Wing Wo store, seen here in 1902, was housed in the Garnier Block on Los Angeles Street for more than 40 years. Today many of the original furnishings of the store can be seen at the Chinese American Museum. (Courtesy El Pueblo Historical Monument.)

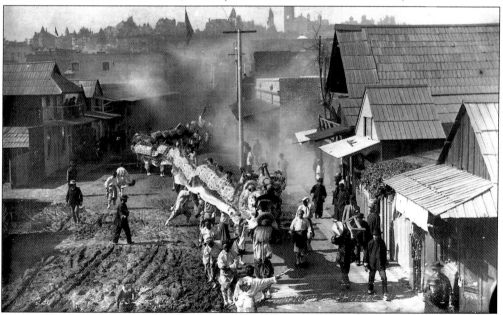
A Chinese New Year parade on Marchessault Street in old Chinatown, looks north toward the plaza, c. 1895. (Courtesy Seaver Center for Western History Research, Los Angeles County Museum of Natural History.)

The Lugos, seen here in front of their "country" house in present-day Bell Gardens, were among the wealthiest and most influential ranchero family in Southern California. In 1838, Don Vicente Lugo built the first two-story adobe on the east side of the plaza. During the 1850s, the building served as a boy's school (today's Loyola High School) and then as St. Vincent's College (1865), the first college in Southern California, which is today's Loyola-Marymount University. By the 1880s, the building was serving as a Buddhist temple and business center for old Chinatown. (Courtesy Seaver Center for Western History Research, Los Angeles County Museum of Natural History.)

In this c. 1890 photograph, the Lugo House served as an important business and religious center for old Chinatown. Despite protests from Chinese elders dressed in Buddhist robes and the Jesuit Fathers of Loyola University, the adobe, which had witnessed much of the city's history, was demolished in 1951. (Courtesy El Pueblo Historical Monument.)

At right in this c. 1880 photograph of the plaza, looking west, is the Plaza Church. To the left of the church is the small, brick house formerly owned by Andrés Pico, younger brother of Pío Pico. Gen. Andrés Pico was a wealthy ranchero during the Mexican and early American periods, commander of Mexican forces in California in the war with the United States, and California state senator during the early American era. (Courtesy J. Paul Getty Museum, Los Angeles.)

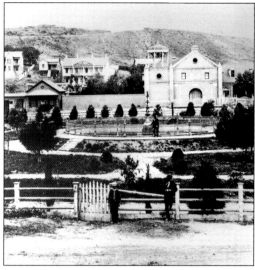

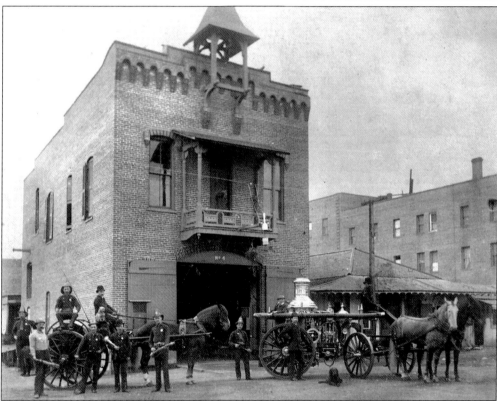

The city's fire department began in 1871 and was made up of volunteers. In 1884, the Plaza Firehouse was constructed, the first building in Los Angeles designed for firefighting equipment and a firefighting crew. Engine Company No. 1 was equipped with a steam-fire engine, a horse cart and three horses, and a crew of 38 volunteers. The building also had a turntable that enabled the horses to pull the fire engine behind them into the building and then go directly into their stalls. The second floor of the brick structure was the living quarters for the fire crew, who would slide down a brass pole when the fire alarm sounded. (Courtesy Los Angeles Public Library.)

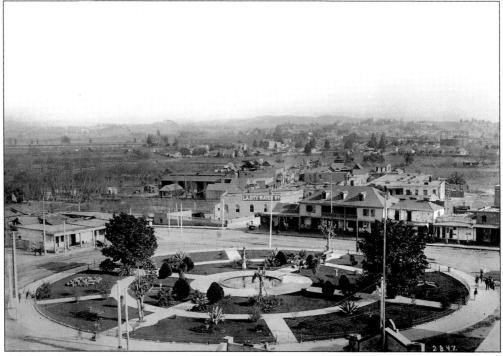

At left in this c. 1880 photograph of the plaza, looking east, is the one-story adobe formerly owned by Agústin Olvera. In the center is the L.A. Water Company, the parent company for today's Los Angeles Department of Water and Power. To the right of the water company is the two-story Lugo House. (Courtesy Los Angeles Public Library.)

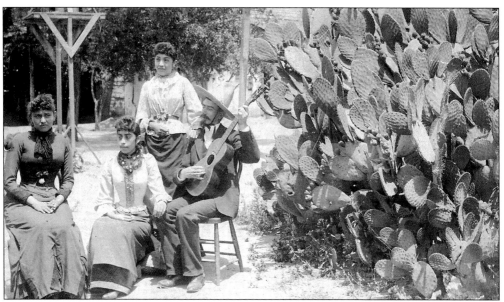

The Ybarras were among the original land grant families of Southern California. In this 1890 photograph, the descendants of Gil Ybarra pose at their home on North Main Street. (Courtesy Seaver Center for Western History Research, Los Angeles County Museum of Natural History.)

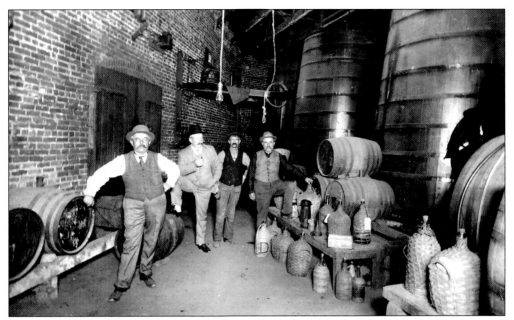

Italians have had a long history on Olvera Street (formerly Wine Street), especially as producers of wine. Carlo Demateis (left) and his brother Giovanni Demateis (far right) rented the old winery from 1901 to 1910 to run their business. Today the building is home to the El Pueblo Gallery. (Courtesy El Pueblo Historical Monument.)

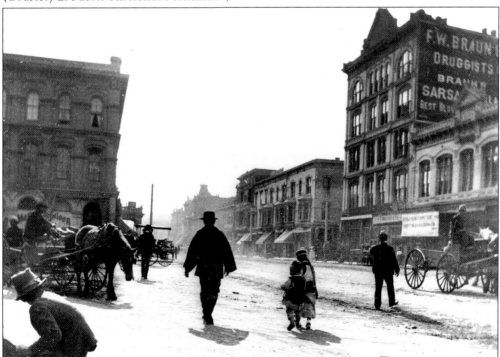

This c. 1890s view of Main Street looks south from Olvera Street, with the Pico House, left, and the F. W. Braun Drug Company (Vickrey/Brunswig Building) on the right. (Courtesy El Pueblo Historical Monument.)

In 1818, the Avila Adobe was constructed by Don Francisco Avila, a prominent ranchero who in 1810 served as alcalde, or mayor, of Los Angeles. With walls over three feet thick, it is the oldest extant house in Los Angeles. Today the adobe has been preserved as a house museum reflecting Los Angeles life in the 1840s and is the most popular site for visitors to Olvera Street. This photograph was taken in c. 1890. (Courtesy Los Angeles Public Library.)

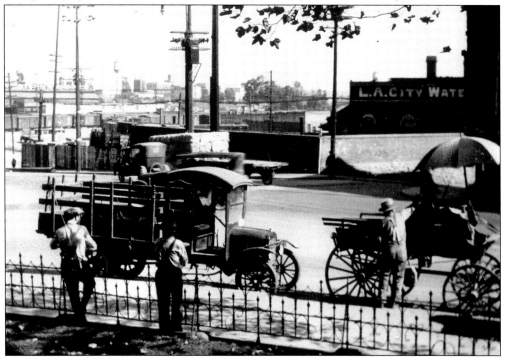

By the late 19th and early 20th century, the plaza was an open-air fruit and vegetable market. In this c. 1919 photograph, a delivery truck and horse buggy stop at the plaza to sell their goods. (Courtesy El Pueblo Historical Monument.)

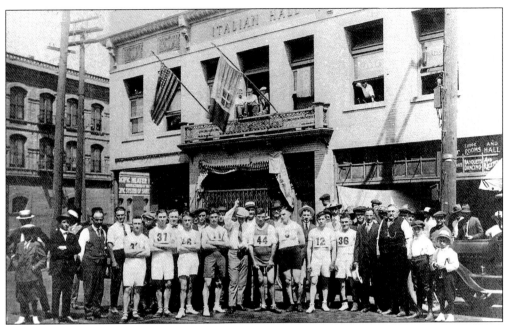

In this 1917 photograph, Italian Hall served as a starting point for a race between the hall and Lincoln Park on Mission Road. Today Italian Hall is undergoing historic preservation and is the future home of the Italian Hall Museum. (Courtesy El Pueblo Historical Monument.)

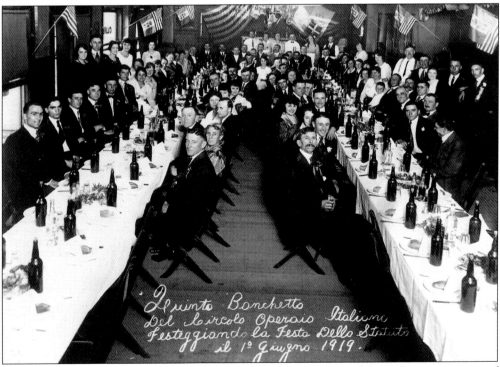

From the mid-19th century to the 1920s, the plaza was the heart of the Italian community of Los Angeles. In this 1919 photograph, Italian men and women of *Il Circolo Operaio Italiano* attend a banquet at Italian Hall on North Main Street. (Courtesy El Pueblo Historical Monument.)

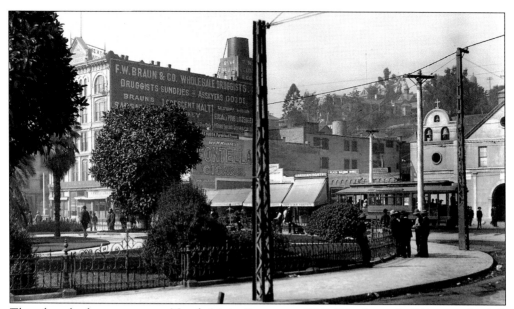

The plaza looks west across North Main Street, c. 1910. The large building to the left is the Vickery/Brunswig Building (1888), home to the F. W. Braun Drug Company, later to become the Brunswig Drug Company. Today the buildings are the site of the future Plaza de Cultura y Artes, a Mexican and Mexican American arts and cultural center. (Courtesy California Historical Society/TI collection.)

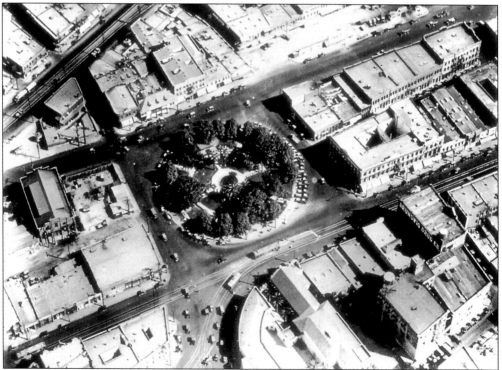

A rare aerial view of the plaza as it appeared in 1922, four years before Christine Sterling's arrival. (Courtesy El Pueblo Historical Monument.)

Two

Christine Sterling and the Birth of the Mexican Marketplace

It is widely known that without the years of unwavering courage and determination by Christine Sterling, affectionately known as the "Mother of Olvera Street," the historic plaza area, which includes Olvera Street, would have fallen to the bulldozer.

She was born Chastina Rix in 1881 in Oakland, California, and was one of four children of Edward Austin Rix and Kate Elizabeth Kittredge. She later changed her name to Christine. She attended Mills College near Oakland to study art and design. But she grew disinterested in her studies, returned home, and married Jerome Hough, a San Francisco attorney. They had two children, a son Peter and a daughter June. Shortly after Peter's birth in 1915, the Hough's moved to Hollywood, where Jerome found work in the early motion-picture industry. They arrived in Southern California just as the Mexican Revolution had come to an end and a flowering of cultural relations between the United States and Mexico created an enormous vogue among Americans for all forms of Mexican art and architecture. This vogue was evident in the 1920s with the arrival of the Mexican masters Diego Rivera and José Clemente Orozco, who painted important murals in the United States. This period was also Hollywood's "Golden Era," the days when Mary Pickford, dubbed "America's Sweetheart," and Rudolph Valentino, "The Great Lover," played some of their most memorable screen roles as romantic Latin characters. Sterling no doubt synthesized this exposure to Hollywood with her family history in San Francisco, her art training at Mills College, as well as her awareness of the emerging influence of Mexican arts and crafts, to develop her overall vision for a Mexican marketplace in the heart of her adopted city.

After her husband's death from a stroke, Christine and her children were in a severe financial crisis. It was at this time in her life that she changed her last name to "Sterling" and began to explore the old historic section of Los Angeles. However, she found it, in her own words, "forsaken and forgotten." So she decided to begin a one-woman campaign to save the city's history, an experience that would change her life.

After several failed attempts to gain public support, she decided to speak with Harry Chandler, publisher of the *Los Angeles Times*. Chandler was immediately intrigued by Sterling's idea for restoring the old Avila Adobe and creating a tourist attraction on Olvera Street. He assigned his leading journalists to report on Sterling's project. However, while local news articles were candid in reporting their affection for the birthplace of Los Angeles and for Sterling, financial support did not come forward. By 1928, her project was fading as she noted in her diary: "Miles of conversation, but no definite, tangible results." Then in late November she found a Department of Health Notice of Condemnation posted on the front of the Avila Adobe. This incident gave her the incentive to post her own hand-painted sign condemning the shortsightedness of city officials for failing to preserve an important historic site. She then gained the support of the Rimpau family of Anaheim, who were the grandchildren and great grandchildren of Don Francisco Avila, builder of the 1818 adobe. The Rimpaus entrusted the adobe to Sterling, who was undaunted in her effort to save the structure. She noted in her diary entry of December 8, 1928, that she made

a large 12-foot sign and placed it in front of the adobe as a means to attract public attention and with a dramatic inscription to passersby to "let the people of Los Angeles show honor and respect to the history of their city by making sacred and inviolate the last of the old landmarks and that spot where the city of Los Angeles was born."

Sterling's written protest attracted public interest in preserving the old adobe. Leading newspapers, especially the *Los Angeles Times*, provided coverage of her campaign to save "old Los Angeles." In response to this show of support, the Los Angeles City Council rescinded their original order of condemnation—the Avila Adobe was saved for future generations. But while the fate of the adobe appeared to have changed, Sterling still needed money to complete the project, which included the transformation of Olvera Street, then a muddy and unpaved alley, into a Mexican marketplace as part of her overall plan for restoring the plaza area. Therefore, to acquire the monies needed, she hosted a barbecue luncheon for city officials on the patio of the adobe, which fronted Olvera Street. The event proved to be a major turning point. At the conclusion of the luncheon, she rose to her feet and asked her guests for their help. Chief of police James Davis responded by announcing that he would provide a crew of prison inmates to do the "hard labor" if others would donate money and materials. In response, Blue Diamond Cement and the Simons Brick Company, staffed by an army of Mexican laborers, pledged building materials. In addition, five prominent downtown businessmen, selected by Harry Chandler, agreed to donate $5,000 each to the project. They formed a for-profit corporation, Plaza de Los Angeles Incorporated, and hired Sterling as managing director.

On September 3, 1929, the city council passed an ordinance to close Olvera Street to vehicular traffic and "to reconstruct it as a place of historic interest." Two months later, Sterling began to record in her diary the ongoing progress of the project. Finally on Easter Sunday, 1930, after four long years of struggle, Christine Sterling's dream was realized with the opening of *Paseo de Los Angeles*, which later became popularly known by its official street name, Olvera Street. Heralded in the local press as "A Mexican Street of Yesterday in a City of Today," Olvera Street was an instant success as a Los Angeles tourist site. *La Opinión*, the leading Spanish language daily newspaper, praised the opening event as *una calleja que recuerda al Mexico viejo* (a typical street that remembers old Mexico). But the struggles were not over.

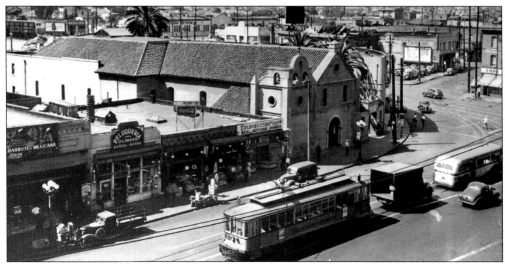

During the late 1930s, buses, trucks, and electric cars rush past the old Plaza Church on North Main Street. Los Angeles had two electric trolley networks: the smaller, yellow cars of the Los Angeles Railway Company, which served metropolitan Los Angeles, and the big Red Cars of the Pacific Electric Railway, which operated the suburban routes. Both companies were owned by Henry E. Huntington. (Courtesy El Pueblo Historical Monument.)

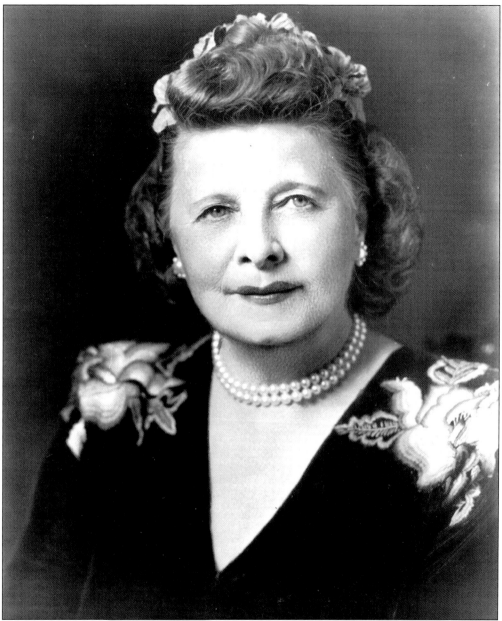

Christine Sterling (1881–1963) was a native of San Francisco who came to Los Angeles and led a campaign to restore the plaza area. During her long career as manager of the birthplace of the city, from 1930 to 1963, she was affectionately known as the "Mother of Olvera Street." (Courtesy El Pueblo Historical Monument.)

Christine Sterling was absolutely fearless at anything she tried. Along with the merchants of Olvera Street, she fought to preserve the birthplace of Los Angeles at a time when few women were challenging city hall. One of her favorite activities was riding her spirited horse, Black Cloud, in the nearby hills of Griffith Park. (Courtesy El Pueblo Historical Monument.)

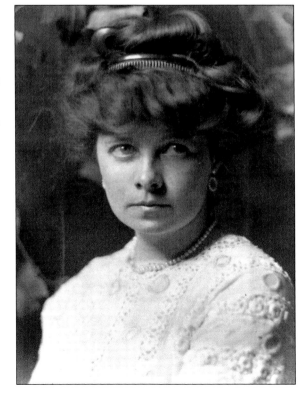

Christine Sterling is pictured here as a young woman of San Francisco at the turn of the century, c. 1900. Her father, Edward Austin Rix, was a noted UC Berkeley scientist. Her grandfather Alfred Rix was elected San Francisco's justice of the peace in 1855 and was also a member of the Vigilance Committee, organized by San Francisco residents to combat the lawlessness and violence during the gold rush. (Courtesy El Pueblo Historical Monument.)

Christine Sterling is dressed as a flapper, the popular style of the Roaring Twenties, around 1921. Her unwavering determination to save the Avila Adobe and create the Olvera Street Mexican marketplace was legendary. During the construction, with support from city hall, local business, and a workforce composed of prison inmates, she wrote the following in her diary: "One of the prisoners is a good carpenter, another an electrician. Each night I pray that they will arrest a bricklayer and a plumber." (Courtesy El Pueblo Historical Monument.)

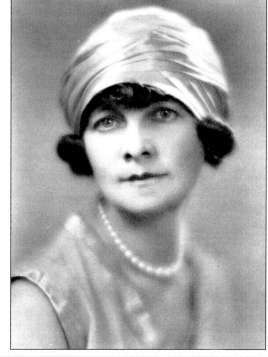

This mid-1920s photograph shows the plaza and the Plaza Church, as it appeared when Christine Sterling first walked down Olvera Street. (Courtesy El Pueblo Historical Monument.)

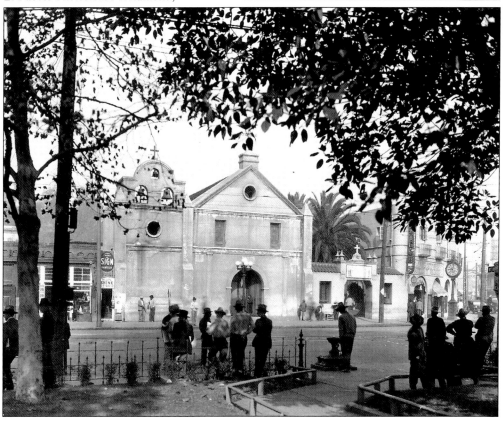

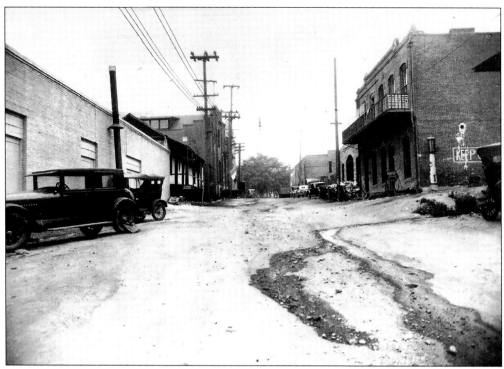

In 1926, Olvera Street was nothing more than an unpaved back alley that was forgotten and slated for demolition. This photograph looks north. (Courtesy El Pueblo Historical Monument.)

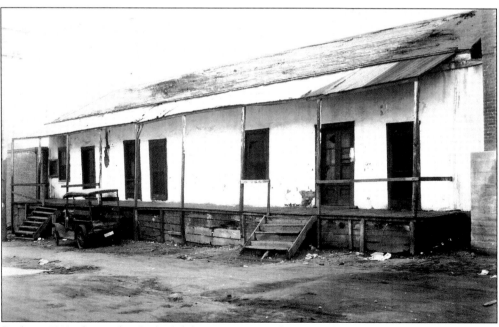

Built in 1818, this is the Avila Adobe as it appeared in 1926 before the restoration effort by Christine Sterling. (Courtesy El Pueblo Historical Monument.)

Harry Chandler (1864–1944) was born in Landaff, New Hampshire. In 1882, to cure his tuberculousis, he came to the warm climate of Los Angeles, where he witnessed the transformation of the city from its Mexican roots to an American metropolis. He eventually became owner and publisher of the *Los Angeles Times* and an Olvera Street benefactor. (Courtesy El Pueblo Historical Monument.)

This condemnation notice was nailed to the front door of the Avila Adobe. Local lore states that this sign inspired Christine Sterling to make her own hand-painted sign that criticized local civic leaders for failing to preserve the city's heritage. She then led a successful campaign to save the old house and create the Olvera Street Mexican marketplace. (Courtesy Los Angeles Public Library.)

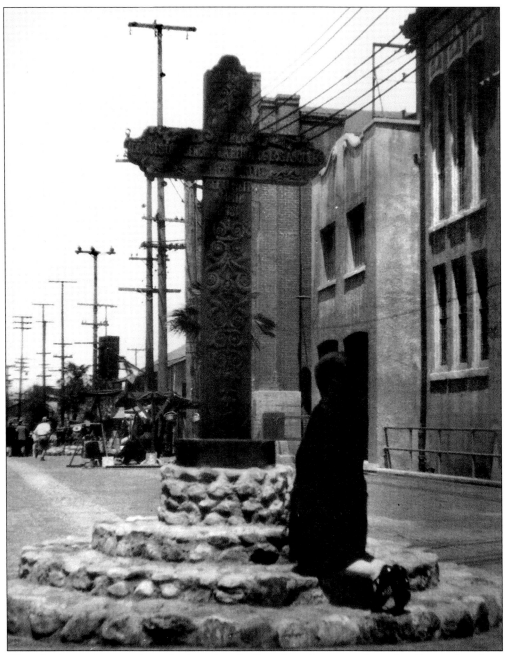

Victoria Arconti, a member of a longtime Italian American merchant family on the plaza, kneels at the Olvera Street cross. The Arcontis were in business around the plaza and on Olvera Street from the 1890s to the 1970s. This photograph was taken in the 1930s. (Courtesy El Pueblo Historical Monument.)

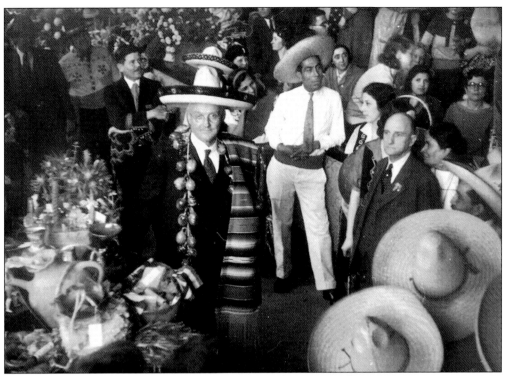
In the 1930s, newspaper mogul Harry Chandler of the *Los Angeles Times* poses in a Mexican serape and sombrero. (Courtesy El Pueblo Historical Monument.)

The back of the Sepúlveda House (1887) and Pelanconi House (1855) on Olvera Street are pictured here before restoration, c. 1928. (Courtesy El Pueblo Historical Monument.)

In late 1929, engineers and workers from the Department of Water and Power began grading Olvera Street. The entire construction project was overseen by Christine Sterling. (Courtesy Los Angeles Public Library.)

Women's organizations were a major source of support for Christine Sterling. Support also came from many historical groups, especially the Historical Society of Southern California. In this 1930 photograph, the Native Daughters of the Golden West lay the last red tiles to formally open Olvera Street as a Mexican marketplace on Easter Sunday. (Courtesy El Pueblo Historical Monument.)

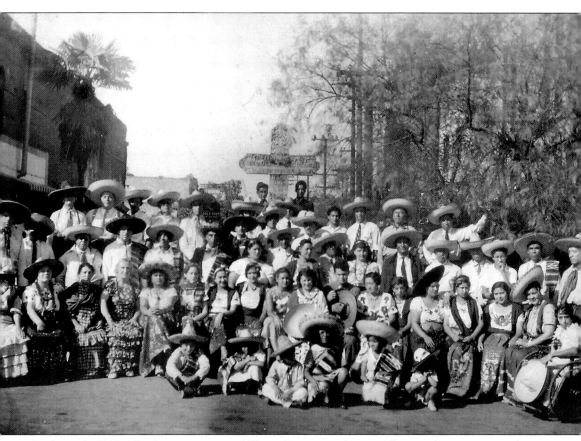

In the early 1930s, the first generation of Olvera Street merchants gathers at the entrance to the new tourist attraction. Many of today's merchants can still trace their origins on the street to 1930. (Courtesy El Pueblo Historical Monument.)

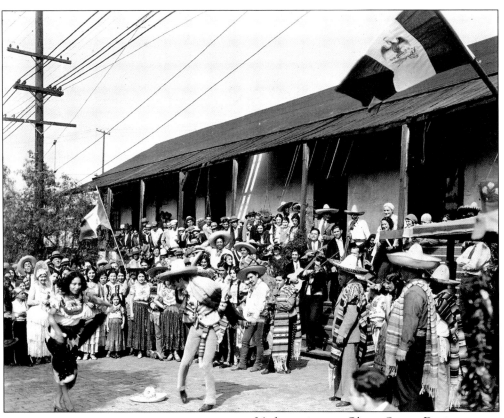

It's fiesta time on Olvera Street. During the 1932 Olympic Games, Olvera Street was listed as an official Olympic venue for the many tourists who came to the city. Today one of the original Olympic Village cabins used by athletes from Mexico—and donated to Olvera Street shortly after the 1932 games—can be found at Casa Suzanna, located at E-16 Olvera Street. In this 1932 photograph, dancers and onlookers enjoy a traditional Mexican celebration in front of the Avila Adobe. (Courtesy El Pueblo Historical Monument.)

Harry Chandler was arguably the most influential figure in early 20th century Los Angeles. Even so, the newspaper mogul often found time to frolic with the children of Olvera Street, as seen in this 1938 photograph. (Courtesy El Pueblo Historical Monument.)

In 1897, Consuelo Castillo de Bonzo was born in Aguas Calientes, Mexico. She crossed the United States-Mexico border with her widowed mother at the beginning of the 20th century. She attended local schools in East Los Angeles and was a devout Catholic. In 1917, she married John Bonzo, an Italian immigrant who lived in her neighborhood in Boyle Heights. She quickly developed her skill as a businesswoman. She began by selling real estate but in 1924, opened La Misión Cafe on South Spring Street. In early 1930, she was offered the old Pelanconi House (1855), the first brick building in the city that was located on the Mexican marketplace that was about to open. She renamed her restaurant La Golondrina Cafe, after a sentimental Mexican farewell song. It was an instant success. From the 1930s to the 1980s, Consuelo de Bonzo was a respected leader in the Mexican American community of Los Angeles. (Courtesy El Pueblo Historical Monument.)

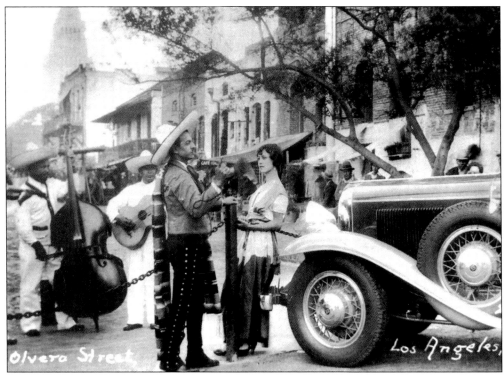

With Los Angeles City Hall in the background, this photograph became a popular Olvera Street postcard of the 1930s. (Courtesy El Pueblo Historical Monument.)

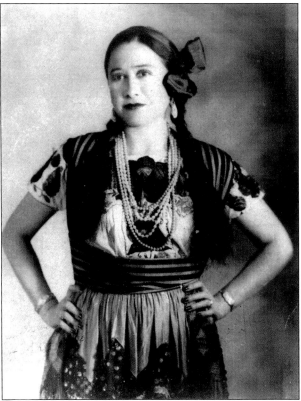

Beautiful Catalina Cruz was a popular Olvera Street merchant during the 1930s and 1940s. She also appeared in several Hollywood movies. Today her descendants can be found operating various businesses on Olvera Street, including Catalina's Imports at E-6 Olvera Street and Leticia Delgadillo's popular Mr. Churro at W-15 Olvera Street (Courtesy El Pueblo Historical Monument.)

Catalina Cruz and fellow merchants pose for the camera in traditional Mexican dress. Many of the original Olvera Street merchants were refugees from the political turmoil and violence of the Mexican Revolution, 1910–1917. (Courtesy El Pueblo Historical Monument.)

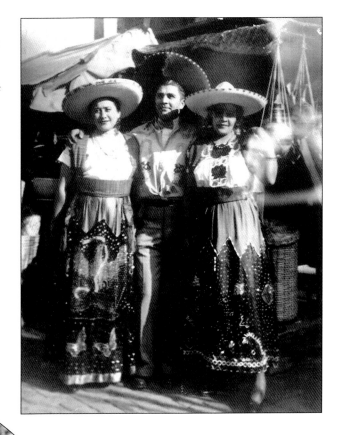

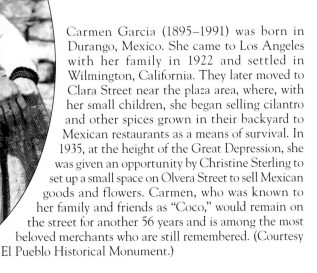

Carmen Garcia (1895–1991) was born in Durango, Mexico. She came to Los Angeles with her family in 1922 and settled in Wilmington, California. They later moved to Clara Street near the plaza area, where, with her small children, she began selling cilantro and other spices grown in their backyard to Mexican restaurants as a means of survival. In 1935, at the height of the Great Depression, she was given an opportunity by Christine Sterling to set up a small space on Olvera Street to sell Mexican goods and flowers. Carmen, who was known to her family and friends as "Coco," would remain on the street for another 56 years and is among the most beloved merchants who are still remembered. (Courtesy El Pueblo Historical Monument.)

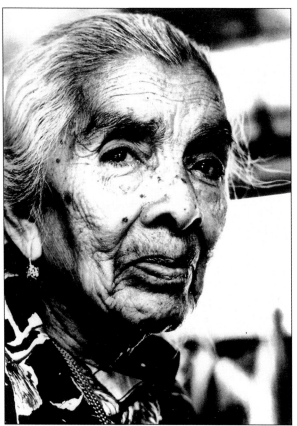

Carmen "Coco" Garcia is pictured here at age 96. In a June 7, 1991, *Los Angeles Times* article on Olvera Street, Garcia said that she intended to live out her days doing what she loved: "Only death will retire me." Three weeks later, her *Los Angeles Times* obituary noted that Garcia had closed her small *puesto* (vendor stall) on June 19 as she had always done, "making change out of an old wooden cigar box." She caught a bus for home and died several hours later. Garcia worked until her last day doing what she loved. Today her son Mike and granddaughters Emily Ramos Martinez, Valerie Garcia Hanley, and Andrea Sanchez, along with their families, continue her legacy as proud merchants on Olvera Street. (Courtesy El Pueblo Historical Monument.)

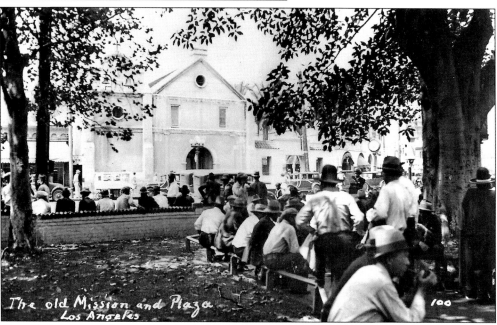

The old plaza was a gathering place for the poor and unemployed during the 1930s, as well as a rallying place for radical labor and political activity. (Courtesy El Pueblo Historical Monument.)

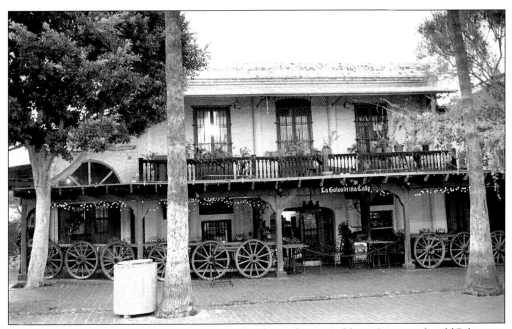

Consuelo Castillo de Bonzo's La Golondrina Cafe is located at W-17 Olvera Street in the old Pelanconi House, the first brick building in Los Angeles, constructed in 1855. Today the famous restaurant is run by her granddaughter Vivian Bonzo. (Courtesy El Pueblo Historical Monument.)

The Velasco family came from the copper mining city of Cananea, Sonora, Mexico. They were steeped in the political and social history of Sonora. One relative from the 19th century, Alfredo Diaz Velasco is today regarded as the poet of Sonora. The family came to Los Angeles in 1919 and established a business on the plaza long before Christine Sterling's arrival in 1926. Today the family business continues on Olvera Street at the Mexico Shop, owned by Albert Gribbell Velasco, and My Rosa Enterprises, owned by Mike and Rosa Mariscal. (Courtesy El Pueblo Historical Monument.)

Pioneer merchant Romualda Sousa, standing in front of her store in 1936, was the mother of Benjamín "Tony" Sousa of Casa de Sousa, today a popular coffee house; Bill Sousa; and Alice (Madrid) Sousa, who, along with her husband, Rudy Madrid, are owners of the popular Olvera Candle Shop. (Courtesy El Pueblo Historical Monument.)

Olvera Street merchants Lupe Santana and Guillermo Lopez pose for the camera outside their *puesto* before going out to celebrate Mardi Gras. (Courtesy El Pueblo Historical Monument.)

In the late 1930s, merchants Belen Guerrero and Juanita Guerrero pose for this photograph. Today the family business on Olvera Street continues with the Robertson and Guerrero families, owners of Las Anitas Cafe (W-26 Olvera Street) and Celito Lindo, located at E-23 Olvera Street and known for their famous taquitos. (Courtesy El Pueblo Historical Monument.)

Early Olvera Street postcards attracted millions of tourists in search of a "little bit of old Mexico" in downtown Los Angeles (Courtesy El Pueblo Historical Monument.)

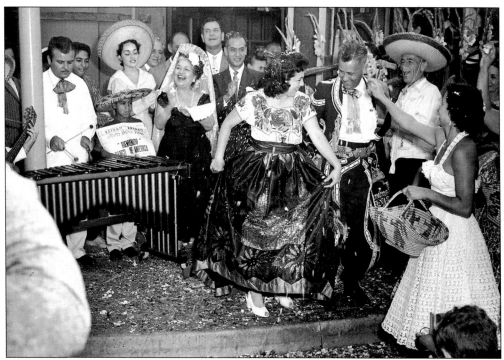

The Simpson/Jones Building was constructed in 1888 to house machinists, plumbers, and other tradespeople. In 1960, the building became a branch of Bank of America. Leading the ceremony in the late 1950s for this new era in El Pueblo Monument's development are Consuelo Castillo de Bonzo and Los Angeles City Council member and future U.S. Congress member, Edward R. Roybal (center), who watch as Mario and Belle Valadez celebrate with a traditional Mexican dance. Today the east section of the building is home to La Luz del Día restaurant, owned by the Berber family at W-1 Olvera Street. (Courtesy El Pueblo Historical Monument.)

Longtime Olvera Street merchant Benjamín "Tony" Sousa (1918–2002) was born in Guadaljara, Jalisco, Mexico, and came to Los Angeles in 1926. The family eventually settled on Michigan Avenue in Boyle Heights. After his father returned to Mexico, his mother, Romualda Sousa, started a small business on Olvera Street. Tony worked with his mother and eventually ran his own business. He became well known for his famous miniatures. After returning from fighting for his country during World War II, he resumed his business. Today, under the operation of his daughter Conchita Sousa, Casa de Sousa is a popular coffee house. (Courtesy El Pueblo Historical Monument.)

Mario Valadez (1906–1989) was born in Gómez Palicio, Durango, Mexico. He came to Los Angeles in 1926 and found work as a window washer while attending night school to learn English. He was then hired by the Spanish Academy as a Spanish teacher and translator. His classes became so popular in the city that he decided to publish a book, *Learn Spanish Pronto*, which sold more than 250, 000 copies. Shortly after Olvera Street opened in 1930, he was asked by the Mexican government to take charge of their tourist office on the street. He accepted the position and decided to combine the tourist service with his Spanish classes. One of his first students on Olvera Street was Christine Sterling. He would later become her assistant and translator for many years. (Courtesy El Pueblo Historical Monument.)

In this 1930s photograph, Christine Sterling poses in a colorful Mexican costume while Benjamín "Tony" Sousa (standing center) and fellow merchants watch. (Courtesy El Pueblo Historical Monument.)

During the early years, Olvera Street's most popular photograph was taken on a real burro (donkey). Today the Hernandez family will take your photograph on "Jorge," their famous stuffed burro at the entrance to Olvera Street. (Courtesy El Pueblo Historical Monument.)

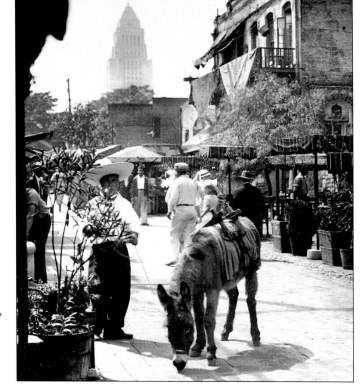

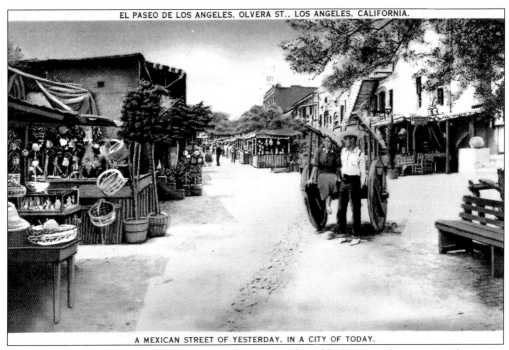
A late 1930s postcard shows Olvera Street. (Courtesy El Pueblo Historical Monument.)

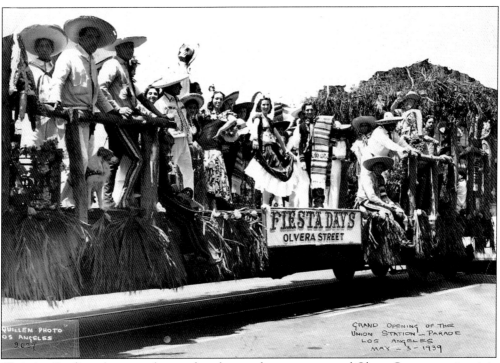
Christine Sterling always made sure that the merchants represented Olvera Street at major civic events. In 1939, an official Olvera Street float took part in the opening of Union Station in a parade that was seen by an estimated crowd of 500,000. (Courtesy El Pueblo Historical Monument.)

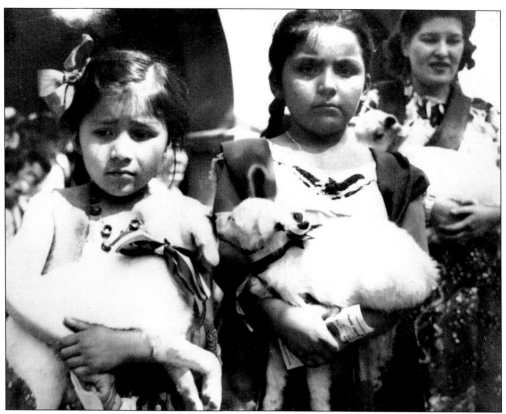

As it was in 1940, the Blessing of the Animals at Olvera Street is a time for children and their pets of all types and sizes. (Courtesy El Pueblo Historical Monument.)

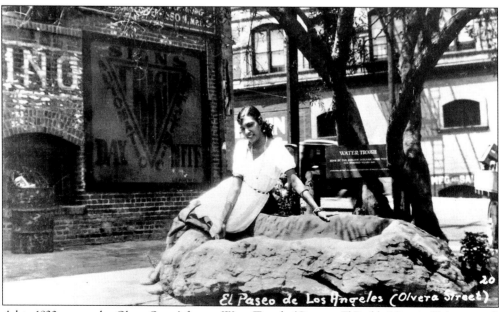

A late 1930s postcard at Olvera Street's famous Water Trough. (Courtesy El Pueblo Historical Monument.)

Three

OLVERA STREET'S GOLDEN YEARS

Olvera Street progressed slowly during its first few years. This was the time of the Great Depression, when millions of Americans were out of work and on public relief. The plaza continued to be a rallying place for free speech and heated political activity, a sharp contrast to the festive atmosphere on Olvera Street. Even so, Sterling and the merchants continued to plan for the future and even made improvements on the street. The small, canvas-covered stands were gradually replaced with wooden *puestos* (vendor stalls) that now run down the center of the street.

In 1932, amidst the excitement of the Olympic games and the trauma of government-sponsored deportations of thousands of Mexican residents in the city, many of which occurred at the plaza, Mexican muralist David Alfaro Siqueiros came to Los Angeles. He was commissioned to paint a large 18-foot by 80-foot mural on the south facing second-story wall of the Italian Hall, a large building at the north end of Olvera Street. The mural was entitled *América Tropical* and was intended to conjure up romantic visions of tropical rain forests, birds, and flowers. Instead he painted an American Indian peon bound on a double cross with what Siqueiros himself described as the eagle of the American coins perched above, talons outstretched. *América Tropical* was painted at a time when Mexican nationals and even some U.S. citizens of Mexican descent were being deported, a scene of injustice that no doubt had an impact on the artist. Reactions to the mural were mixed. While the administrators of Olvera Street, especially Sterling, were dismayed, the art world was enthusiastic. Unfortunately Siqueiros was deported and one-third of the mural visible from Olvera Street was whitewashed. The remaining portion was painted out over the proceeding years.

Other activities during this time included the Yale Puppeteers in the Sepúlveda House, with Forman Brown and his fellow puppeteers charming nightly audiences. The Leo Carrillo Theatre also brought live dramatic performances to Olvera Street in the Machine Shop Building, where Casa California is now located. The 1930s were certainly a time when Olvera Street grew in popularity as an historic landmark and tourist venue for local residents, Hollywood movie stars, and even world dignitaries such as First Lady Eleanor Roosevelt, who came in 1939 to buy the famous Olvera Street candles and do "a little bit of Christmas shopping."

During World War II, while mobs of servicemen and civilians assaulted Mexican youth in downtown—the so-called Zoot Suit Riots of 1943—Mexican American men and women served in all branches of the military and were an important part of the wartime labor force at home. On Olvera Street, a USO Canteen opened in the Sepúlveda House for the thousands of troops arriving at Union Station.

The postwar years were marked by economic gain for the city and the nation as a whole. Cold war military spending stimulated high employment levels and consumer demand. The 1950s continued the prosperity of the war years for Olvera Street. Throughout this period, while Mexican consular, community, and business leaders such as Dr. Reynaldo Carreon and Consuelo Castillo de Bonzo continued to sponsor traditional patriotic observances at the plaza (such as Cinco de Mayo and *el diez-y-seis de septembre* (September 16, Mexican Independence Day), Christine Sterling and her assistant, Mario Valadez, presided over other traditional yearly events, such as *Las Posadas*, the Blessing of the Animals, and the city's birthday. And, in 1953, with the aid of her many

supporters and local historical groups, the 44-acre area around the plaza, which includes Olvera Street, became a California State Historic Park. This designation was an important step in the future development and restoration of the plaza area. In June 1953, the state and City and County of Los Angeles signed the first of several Joint Powers Agreements. Under this agreement, the properties in the 44-acre area designated as the state historic park were to be acquired through the right of eminent domain. The state provided $750,000, which was matched by $375,000 each from the city and the county. In 1954, a new corporation was formed to manage Olvera Street. Harry Chandler's original for-profit Plaza de Los Angeles Incorporated was replaced by a nonprofit organization, El Pueblo de Los Angeles Corporation. In 1955, the state contracted with the City and County of Los Angeles for the operation of the park and for developing a master plan. The state also approved a new agreement whereby the Los Angeles Department of Recreation and Parks would administer the park, while El Pueblo de Los Angeles Corporation would continue to manage Olvera Street. Meanwhile the city would undergo a period of dramatic change.

By the end of the decade, the rapid pace of urban development, marked by new freeways and towering skyscrapers, transformed much of downtown Los Angeles. Eminent domain, which is the legal right for government to acquire private property for public use, uprooted downtown communities in Chavez Ravine and Bunker Hill. Since 1938, Christine Sterling had been listed in the city directory as a resident of 935 Chavez Ravine Road. Thus, when the city eviction notices were posted, she lost her small home in Chavez Ravine, along with several Mexican and Italian families who were forced out of their neighborhood in order to make way for Dodger Stadium. She moved into the Avila Adobe—the home she had rescued years before now offered shelter. But as age and failing health set in, she relinquished her authority to Mario Valadez, who for many years had assisted her in managing the daily business affairs of Olvera Street.

On the morning of June 21, 1963, Christine Sterling died at age 82 in her sleep in the old adobe—a fitting end to a remarkable life that was both inspired and transformed by the humble structure she first encountered in 1926. Who will ever forget the "Mother of Olvera Street," who dedicated so much of her life to help Los Angeles recover its forgotten history?

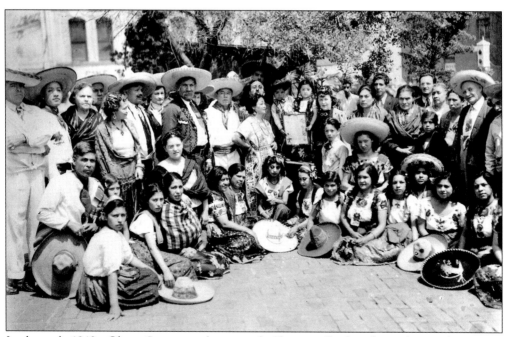

In the early 1940s, Olvera Street merchants, with Christine Sterling (center), pose for a group photograph. (Courtesy El Pueblo Historical Monument.)

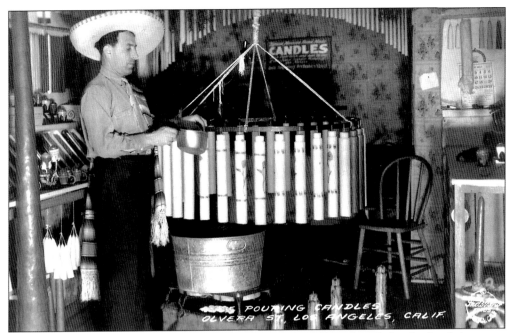

Francisco "Pancho" Gonzalez was a famous Olvera Street candle maker. Today the family business, run by Robert and Gayle Gonzalez, continues at Veleria Candles, located at W-14 Olvera Street. (Courtesy El Pueblo Historical Monument.)

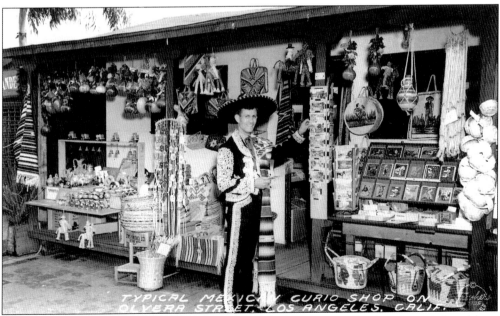

Mario Valadez stands in front of his famous *puesto*, which was originally a housing unit for athletes during the 1932 Los Angeles Olympic games. (Courtesy El Pueblo Historical Monument.)

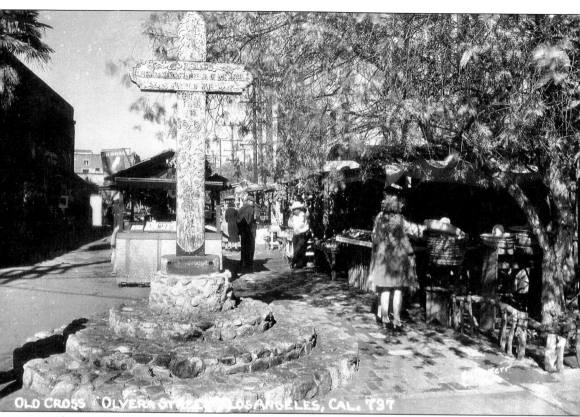

This 1940s postcard of Olvera Street looks north from the wooden cross. Today the woman looking at sombreros in this postcard would be in front of Augusto Godoy's busy *puesto* at E-2 Olvera Street and she would be shopping for beautiful purses, belts, and other leather items. (Courtesy El Pueblo Historical Monument.)

Ironically, this February 1931 front page of *La Opinión*, the leading Spanish language daily in the city, reported that while Olvera Street was celebrating its first year as the city's most popular tourist attraction, Mexican residents were being apprehended and deported from the plaza, only a few feet away from the new theme park that predates Disneyland by 25 years. (Courtesy *La Opinión*.)

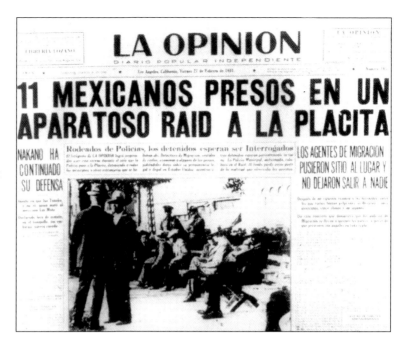

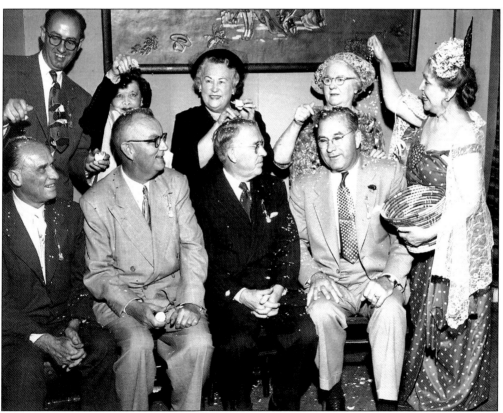

Since their first meeting in 1929, Christine Sterling and Consuelo de Bonzo knew how to charm elected officials in order to gain support for Olvera Street. (Courtesy El Pueblo Historical Monument.)

Handsome Mike Garcia, son of Carmen Garcia, started out as a shoeshine boy on Olvera Street. Today with his wife, Norma, and daughter Valerie Garcia Hanely, he is the owner of Casa California, located at W-10 Olvera Street. (Courtesy El Pueblo Historical Monument.)

Arcadio Santana and Margarita Garcia pose for the camera in the 1940s. Today Margarita's memory is carried on by her daughter Emily Ramos Martinez and son-in-law Peter Martinez at the popular *puesto* that bares her name at C-7 Olvera Street. (Courtesy El Pueblo Historical Monument.)

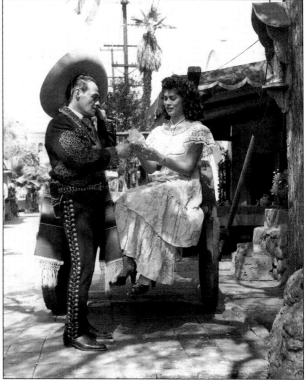

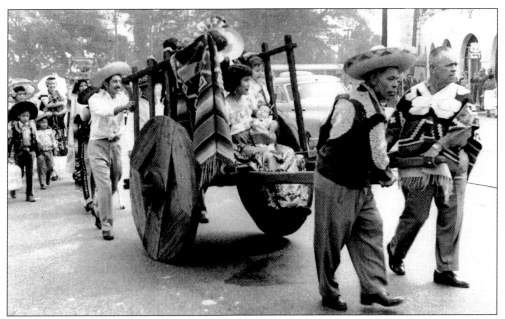
Olvera Street merchants proudly display their culture in a 1940s parade for the Blessing of the Animals around the plaza. (Courtesy El Pueblo Historical Monument.)

In 1941, Maria Elena Peluffo's Café Caliente, located in the old Winery building, was among the most popular nightclubs in downtown, where Hollywood movie stars dined and danced until the early hours of the morning. Today it is home to Andy Camacho's popular El Paseo Inn restaurant. (Courtesy El Pueblo Historical Monument.)

During World War II, Olvera Street's USO Canteen in the Sepúlveda House was a welcome place of relaxation for the thousands of United States soldiers who passed through Union Station on their way to the battlefields of Europe and the Pacific. This picture was taken in 1943. (Courtesy El Pueblo Historical Monument.)

Arcadio Santana came to Los Angeles from Mexico with very little money but lots of determination. In this c. 1945 photograph, he is proudly dressed as a Mexican *charro*. (Courtesy El Pueblo Historical Monument.)

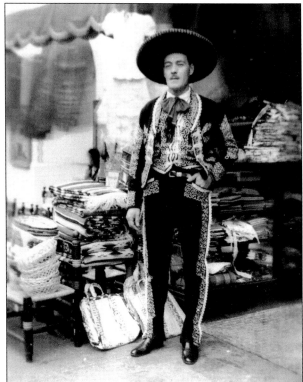

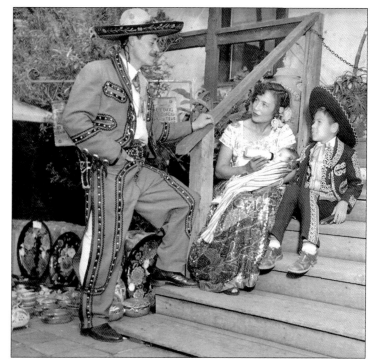

Merchants Arcadio and Lupe Santana were married in 1937 in Juarez, Mexico, and came to Los Angeles in 1942. They immediately fell in love with Olvera Street. In this c. 1948 photograph, they pose with their two children in front of the Avila Adobe. (Courtesy El Pueblo Historical Monument.)

During the 1940s, Mexican sugarcane was a favorite treat among the many children of Olvera Street and it sold for only 5¢. (Courtesy El Pueblo Historical Monument.)

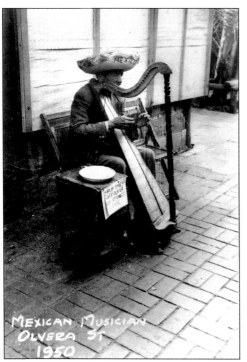

Olvera Street musicians have been a familiar scene from the street's humble beginnings in 1930. (Courtesy El Pueblo Historical Monument.)

The Olvera Street Theatre was located in the old Machine Shop Building (1910–1920) and delighted thousands of visitors during the 1940s and 1950s. Today it is home to Mike and Norma Garcia's beautiful Casa California at W-10 Olvera Street, one of the largest shops on the street. (Courtesy El Pueblo Historical Monument.)

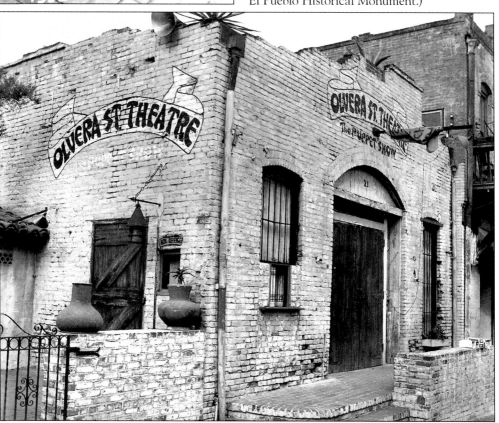

One of Olvera Street's most unique and celebrated merchants was the famous blacksmith Cruz Ledesma, c. 1970. This photograph appeared in *Look Magazine*. (Courtesy El Pueblo Historical Monument.)

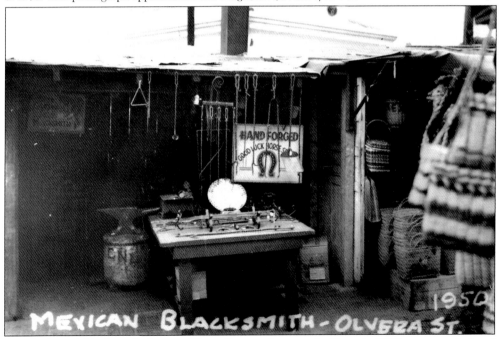

Cruz Ledesma's blacksmith shop on Olvera Street, photographed here in 1950, was a reminder of Los Angeles during old ranchero days. (Courtesy El Pueblo Historical Monument.)

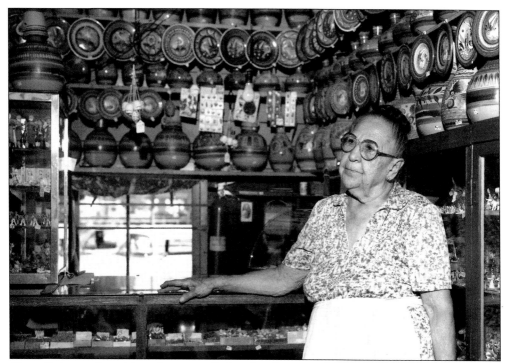
Clara Ruiz was loved by all, especially by the throngs of shoppers looking for authentic Mexican pottery at her beautiful Guadalajara Curio Shop at E-19 Olvera Street. (Courtesy El Pueblo Historical Monument.)

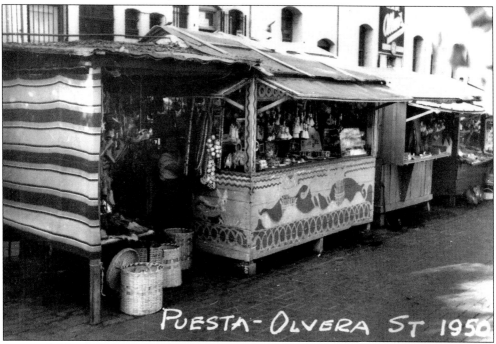
A typical Olvera Street *puesto* (stall) is pictured in 1950. Today the wooden *puestos* look much like the originals. (Courtesy El Pueblo Historical Monument.)

No matter what time period or occasion, Olvera Street has always been a place for children. (Courtesy El Pueblo Historical Monument.)

In 1953, the birthplace of Los Angeles became a California State Historic Park. This was a major accomplishment for the future of Olvera Street and for historic preservation of the plaza area. Major supporters of this effort were Judge McIntyre Faries (left), Christine Sterling, California assembly member Jonathan Hollibaugh, and Florence Dodson de Schoneman, a descendant of the Sepúlveda family, which formerly owned Rancho Los Palos Verdes. (Courtesy El Pueblo Historical Monument.)

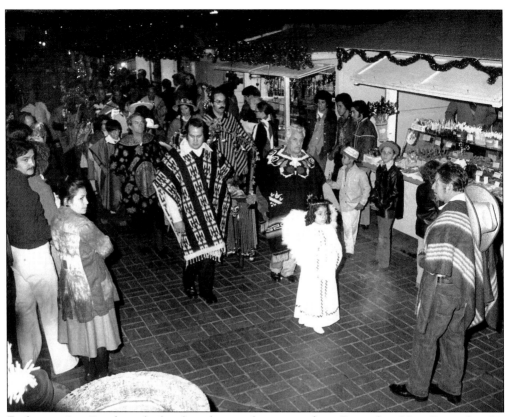

Each year, *Las Posadas*, which takes place each evening from December 16 to December 24, has been Olvera Street's way of bringing a Mexican Christmas to Los Angeles. The candlelight procession depicts the nine-day journey of Mary and Joseph to Bethlehem. It includes singing and entertainment. Hot *champurado*, *pan dulce*, and the breaking of the piñata with plenty of candy inside are also part of this cherished event. (Courtesy El Pueblo Historical Monument.)

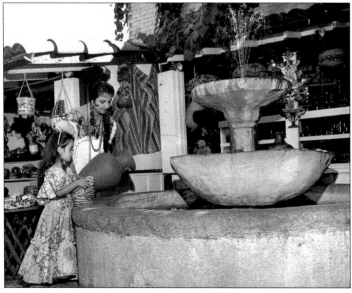

In the 1960s, merchant Irma Tapia and her daughter Estrellita draw water from the Olvera Street fountain. (Courtesy El Pueblo Historical Monument.)

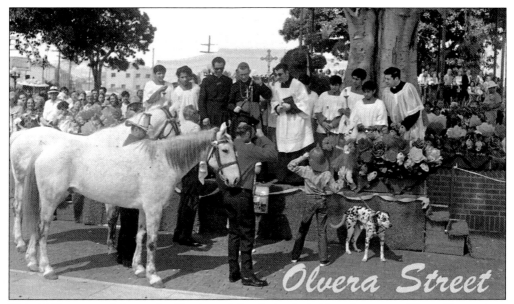

This 1960s postcard shows the Blessing of the Animals, held each year on Olvera Street since 1930 on the Saturday before Easter. In a religious ceremony that some say has its origins with St. Francis of Assisi, protector of animals, or San Antonio de Abad (St. Anthony of the Desert), each year people form a parade and bring their animals and pets before the padre, or priest, to be blessed for fertility and good health. (Courtesy El Pueblo Historical Monument.)

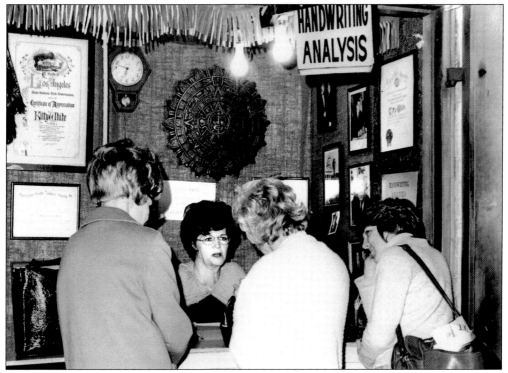

In the 1960s, handwriting analyst Kitty White, an Olvera Street favorite, fascinated visitors from around the world. (Courtesy El Pueblo Historical Monument.)

Longtime merchant Joe Ramos was born in 1909 in Michoacan, Mexico, and came to Los Angeles with his family in 1916 to escape the violence of the Mexican Revolution. Recently retired after more than 40 years on Olvera Street, where he sold his famous paper flowers and Mexican curios. He is known by all for his great smile. (Courtesy El Pueblo Historical Monument.)

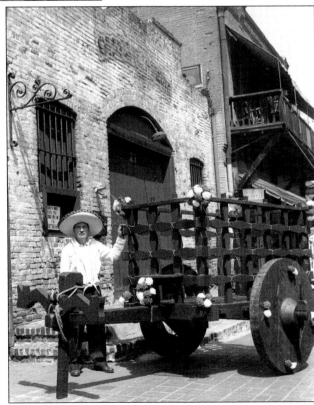

In 1961, merchant Nash Zamora proudly stands by his handcrafted Mexican *carreta*. (Courtesy El Pueblo Historical Monument.)

In 1949, longtime Olvera Street merchant Meloni Tanzini, who was born in Philadelphia, poses at the fountain with an employee during Mardi Gras. Now in his 80s, he still runs his Casa Carolina shop and walks in the yearly *Las Posadas* procession. (Courtesy El Pueblo Historical Monument.)

In 1947, Christine Sterling told the story of her struggle to save the plaza area and to create Olvera Street in this popular little book that sold thousands of copies. (Courtesy author.)

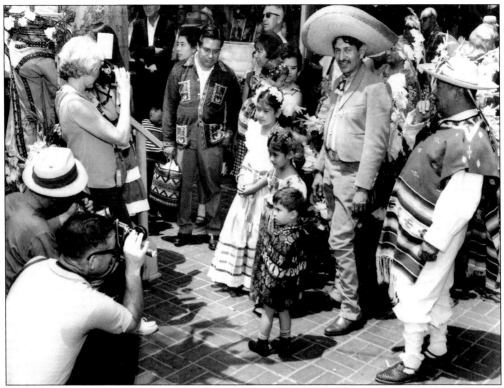
Cruz Ledesma and fellow merchants were always happy to pose for the camera in this 1950s photograph. (Courtesy El Pueblo Historical Monument.)

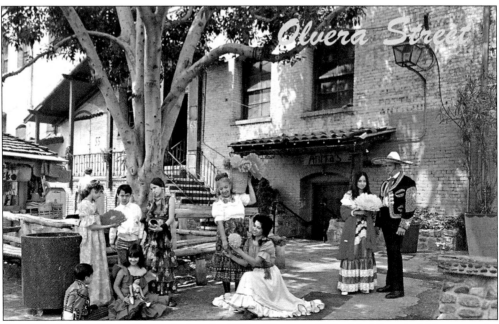
A postcard shows Olvera Street during the 1970s. (Courtesy El Pueblo Historical Monument.)

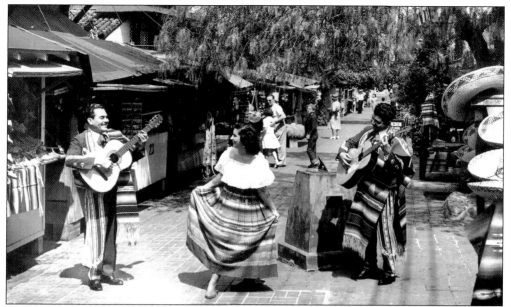

In the 1960s, lovely Alice (Madrid) Sousa (Olvera Candle Shop, W-3) is serenaded on Olvera Street next to the famous sundial. (Courtesy El Pueblo Historical Monument.)

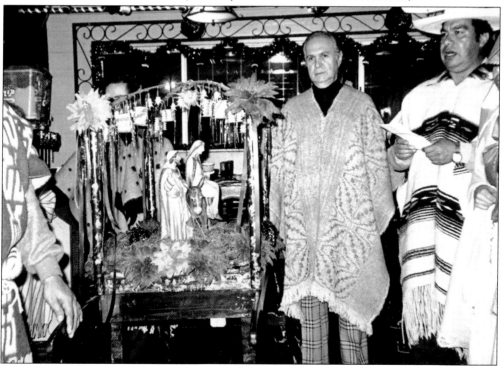

In this 1960s photograph, longtime Olvera Street merchants Armando Bernal, center, owner of Casa Bernal, who came to Los Angeles from Durango, Mexico, in 1926, and leather merchant Rafael Caballero, who sells authentic Mexican *huaraches* (leather sandals) at his shop at C-11, lead the procession for *Las Posadas*. In 2006, Bernal will celebrate his 62nd year on Olvera Street. (Courtesy El Pueblo Historical Monument.)

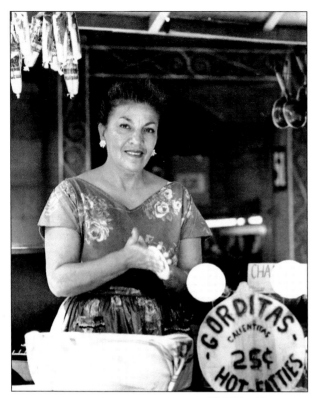

In the 1950s, Olvera Street merchant Belle Tapia is making her famous gorditas. Longtime merchants remember her talent in all forms of Spanish and Mexican dance. As a teenager, the beautiful Belle stood in as a dancer for Mary Pickford and other stars of the silent screen. (Courtesy El Pueblo Historical Monument.)

Merchant Irma Tapia and daughter Estrellita, who once lived in the Sepúlveda House, still manage their shop, Las Trancas, at C-25 Olvera Street. (Courtesy El Pueblo Historical Monument.)

Pictured in 1986, Christina Mariscal, a recent college graduate, and Vivian Bonzo, owner of La Golondrina Cafe, are the children, grandchildren, and great-grandchildren of longtime Olvera Street merchant families. (Courtesy El Pueblo Historical Monument.)

In the 1980s, Christina Mariscal, the "little angel," leads the procession for *Las Posadas*. She is followed by her parents, Mike and Rosa Mariscal, owners of My Rosa Enterprises, who are dressed as Joseph and Mary. (Courtesy El Pueblo Historical Monument.)

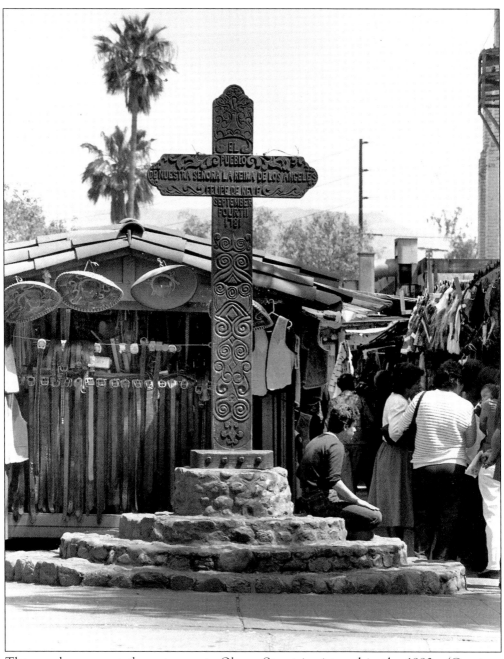

The wooden cross at the entrance to Olvera Street is pictured in the 1980s. (Courtesy El Pueblo Historical Monument.)

Four

FAMOUS FACES FROM NEAR AND FAR

Almost from the beginning, Olvera Street has attracted the heads of church and state from around the world, as well as renowned artists, writers, Hollywood movie stars, and local celebrities.

In 1826, Jedediah Smith and his band of fur trappers were the first party to reach Los Angeles overland from the United States. They are believed to have entered the pueblo through Vine or Wine Street—later to become Olvera Street. During the late 19th century, Pío Pico, John C. Fremont, and Helen Hunt Jackson no doubt passed each other while riding their horse-drawn buggies on Olvera Street. In the 1880s, Madame Helena Modjeska, the great actress of the Polish and San Francisco stage and her husband, Count Bozenta Chlapowski, came to the plaza and stayed at the Pico House. Other dignitaries of the 20th century include First Lady Eleanor Roosevelt, John. F. Kennedy, Richard Nixon, and Cantinflas. Pope John Paul II passed by the street in the Pope mobile, and the King and Queen of Spain came to preside over the installation of a statue of King Carlos III.

In the early days of silent movies, Charlie Chaplin, Buster Keaton, and Harold Lloyd had numerous scenes filmed in and around Olvera Street. As a young girl, Myrtle Gonzalez, the great star of the silent era that rivaled Mary Pickford, helped her father run his small grocery store located only a few steps from Olvera Street.

From the 1930s through the 1950s, the largest restaurants on Olvera Street, including Consuelo de Bonzo's La Golondrina Cafe, and Maria Elena Peluffo's El Paseo Inn (formerly the Café Caliente), were popular after-hour nightclubs among the Hollywood movie crowd. Screen idols such as Lauren Bacall, Humphrey Bogart, George Raft, Rita Heyworth, Orson Wells, Ida Lupino, and Johnnie Weissmuller (Tarzan) were regular patrons of the night clubs, which featured live entertainment and rarely closed before the early hours of the morning. In 1951, 16-year-old Rita Moreno, who would later star in *Westside Story*, had her film debut in *The Ring*, a story that revolved around a Mexican American family on Olvera Street. Indeed, Hollywood movie directors have found Olvera Street and the plaza area to be a favorite location. Charles Bronson chased the bad guys in *Death Wish 2* (1982), Mel Gibson and Danny Glover enforced the law in *Lethal Weapon 3* (1992), Tobey Maguire prepared for his destiny with *Seabiscuit* (2003), and Brad Pitt and Angelina Jolie danced the night away in the courtyard of the Avila Adobe for the recent blockbuster, *Mr. & Mrs. Smith* (2005). Recently Academy Award winner Sir Ben Kingsley stopped by for a tour of the Avila Adobe.

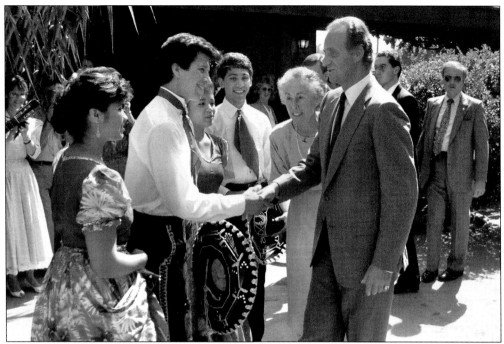

In 1987, King Juan Carlos I of Spain (far right) is greeted by members of the Vallejo family, who danced professionally as the Algegre Family Dancers, in the courtyard of the Avila Adobe. Pictured, from left to right, are Ceciley, Gary, Cynthia, and Mark Vallejo, El Pueblo senior curator Jean Bruce Poole, and King Juan Carlos. (Courtesy El Pueblo Historical Monument.)

In 1921, silent movie great Charlie Chaplin filmed one his most memorable movies on Olvera Street, *The Kid*. Chaplin is pictured here rescuing his six-year-old costar Jackie Coogan from the orphanage police.

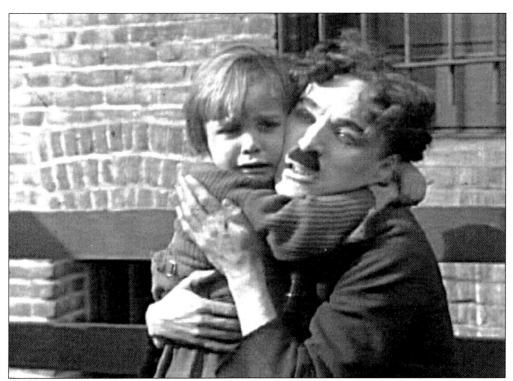

A close-up of the same scene on Olvera Street, with Charlie Chaplin and Jackie Coogan. Chaplin (1889–1977) appeared in many other short films and features, such as *The Kid*, as his bowler-hatted persona, the "Little Tramp." During the 1960s, Coogan brought laughs to millions of television viewers as Uncle Fester in *The Addams Family*.

In 1932, renowned Mexican artist David Alfaro Siqueiros (1896–1974) came to Olvera Street to paint the mural *América Tropical* on an outside wall of the Italian Hall. Today *América Tropical* is considered a Los Angeles art treasure and is undergoing conservation. (Courtesy El Pueblo Historical Monument.)

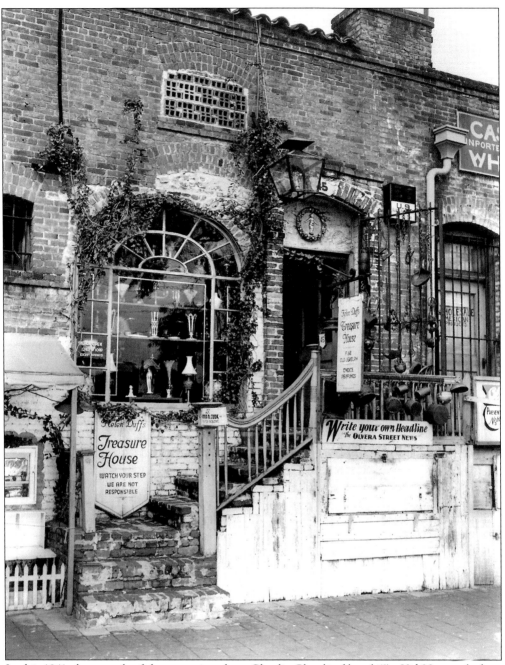

In this 1941 photograph of the same site where Charlie Chaplin filmed *The Kid* 20 years before, Helen Duff's Treasure House welcomes shoppers. Today the upper floor of the building is home to merchant Meloni Tanzini's Casa Carolina, located at W-21 Olvera Street. On the first floor is Albert Gribbell Velasco's popular Mexico Shop, located at W-20 Olvera Street. (Courtesy El Pueblo Historical Monument.)

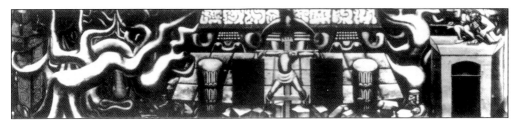

This is a black-and-white photograph of *América Tropical* by David Alfaro Siqueiros. Today Los Angeles is home to the world's largest display of public murals, and *América Tropical*, currently undergoing conservation, is considered to be the inspiration for the Chicano and Chicana mural movement. (Courtesy El Pueblo Historical Monument.)

In 1939, First Lady Eleanor Roosevelt was given a VIP tour of Olvera Street by Christine Sterling. Since the early years of her husband's administration, she was a regular visitor to Olvera Street. On this particular visit to the city, according to the *Los Angeles Times*, she returned to the birthplace of the city "to do a bit of early Christmas shopping" and to express her gratitude to the Olvera Street candle maker for a previous gift. (Courtesy El Pueblo Historical Monument.)

Christine Sterling was never one to miss an opportunity for public support. During their 1939 tour of Olvera Street, she guided the first lady two blocks north to view her new China City project, where Mrs. Roosevelt admired the drama and "authenticity" of The Good Earth set. (Courtesy El Pueblo Historical Monument)

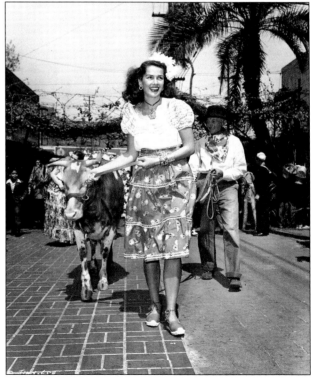

Beautiful Jinx Falkenburg, star of Columbia's *The Gay Señorita* in 1945, leads the procession on Olvera Street for the Blessing of the Animals. (Courtesy Columbia Pictures/El Pueblo Historical Monument.)

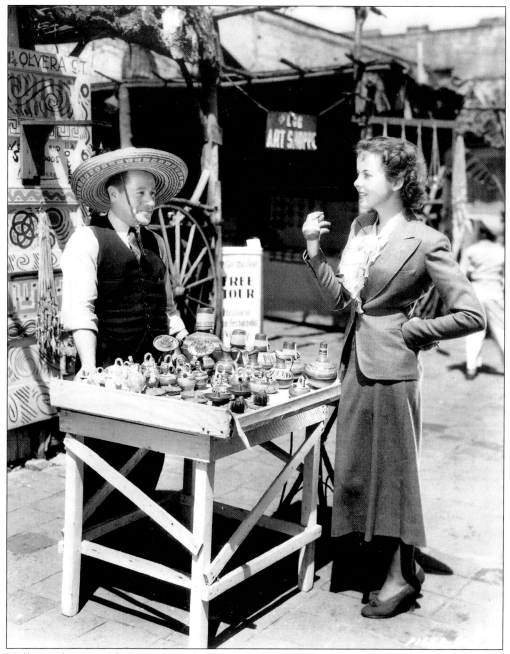

Hollywood actress Ida Lupino was born in London to a show business family. Her father was famed British comedian Stanley Lupino and her mother, Connie Emerald, was an actress. In most of her movies, the bleached blonde was cast as a tough, but sympathetic woman from "the wrong side of the tracks." Lupino went on to become a pioneering director and was only the second woman admitted to the Directors Guild. During the 1940s and 1950s, she was an Olvera Street regular, where her younger sister worked as a dancer at El Paseo Inn restaurant. (Courtesy Bison Archives.)

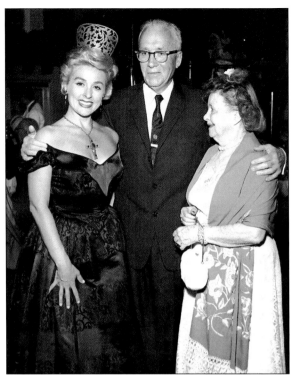

In 1952, Hollywood actress Elena Verdugo, Judge McIntyre Faries, and Christine Sterling attend an Olvera Street fiesta. Verdugo, who appeared in her first film in 1931, would later go on to portray nurse Consuelo Lopez in the popular television drama, *Marcus Welby, M.D.*, which ran from 1969 to 1976 and starred Robert Young and James Brolin. The professional talent and dignity that Verdugo brought to this role is considered to be a breakthrough for Latinos in film and television. (Courtesy El Pueblo Historical Monument.)

In the 1940s, Hollywood actress Betty Furness learns the art of candle making from Francisco Gonzalez. His candle shop, where the famous scented candles began, is still run by his family in the basement of the old Sepúlveda House. (Courtesy El Pueblo Historical Monument.)

Los Angeles mayor Sam Yorty (1961–1973), a Nebraska-born son of Irish immigrants, along with Elizabeth Yorty, always enjoyed his visits to Olvera Street—especially to sample the Mexican food. In this late 1960s photograph, the ever colorful and controversial mayor is receiving a new sombrero and serape from Olvera Street manager Mario Valadez. (Courtesy El Pueblo Historical Monument.)

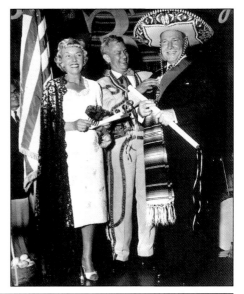

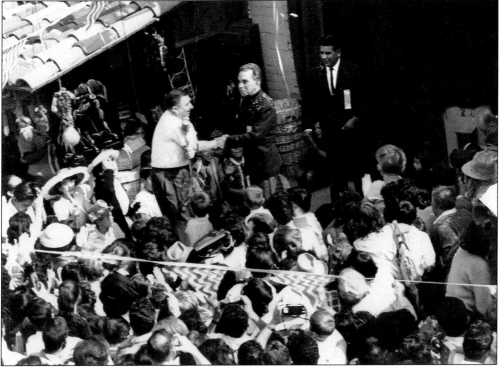

In 1969, renowned Mexican comedian/actor/producer Mario Moreno Reyes, also known as "Cantinflas," came to Olvera Street. The star of more than 55 films was greeted by a large crowd, and Olvera Street merchant Joe Ramos served as master of ceremony. When he died in 1993, Cantinflas was hailed by the Mexican government as a national hero. Despite the fact that he was a millionaire several times over, Cantinflas never forgot where he came from. Much of his money was given over to charitable work for Mexico City's poor. Moreno once was described as "the world's greatest comedian" by none other than Charlie Chaplin. (Courtesy El Pueblo Historical Monument.)

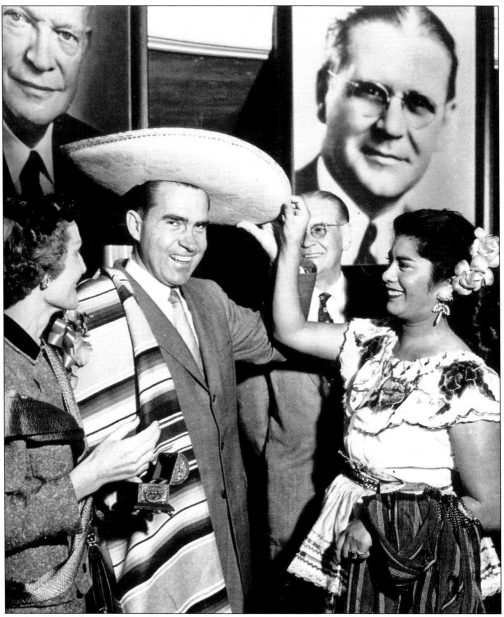

In the 1950s, future United States president, Richard M. Nixon (1969–1975), future first lady Pat Nixon, and Olvera Street merchant Margarita Garcia enjoy a light moment on the campaign trail. (Courtesy El Pueblo Historical Monument.)

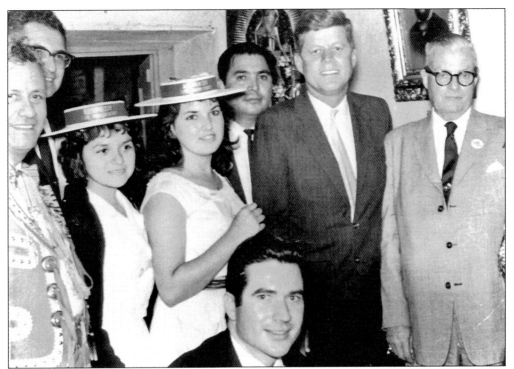

United States senator John F. Kennedy visited the Avila Adobe during his 1960 campaign for president. During this historic visit, the future president had his first Mexican lunch and even took a short nap in the old adobe. Kennedy, the first Roman Catholic U.S. president (1961–1963), credited the support he received from the Mexican American community as a key to his victory—support that began on Olvera Street. (Courtesy El Pueblo Historical Monument.)

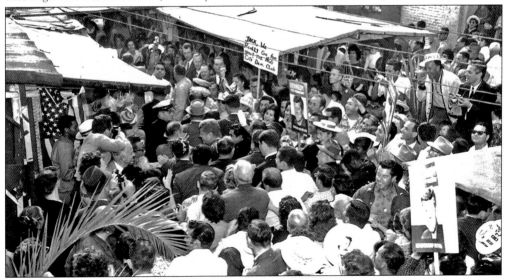

After leaving the Avila Adobe, Senator Kennedy (center left) was surrounded by a crowd of supporters on Olvera Street. The shouts of "Viva Kennedy" were heard all the way to Washington, D.C., and certainly by the future first lady, Jacqueline Kennedy, who was fluent in Spanish. (Courtesy El Pueblo Historical Monument.)

In the 1960s, popular television host and author Art Linkletter—*People Are Funny, House Party,* and *Kids Say the Darndest Things*—and his wife, Lois, dressed in their finest Spanish lace and satin for an Olvera Street fiesta. (Courtesy El Pueblo Historical Monument.)

In the 1970s, California governor Edmund G. Brown visits Olvera Street and samples the delicious fruit prepared by merchant Fidel Velarde. (Courtesy El Pueblo Historical Monument.)

Olvera Street blacksmith Cruz Ledesma poses with 1981 Rose Queen Leslie Kawai, Lourdes Vega, and Olvera Street leather merchant, Manuel Murillo, and Isaias Salazar. (Courtesy El Pueblo Historical Monument.)

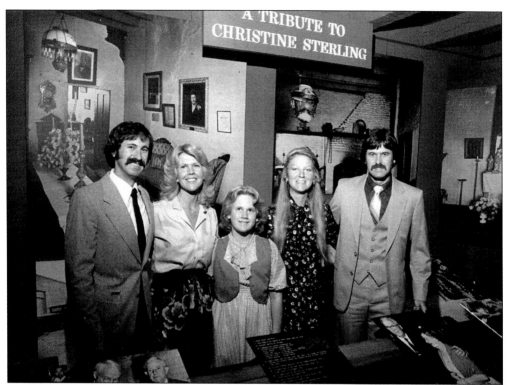

Christine Sterling's grandchildren and great-grandchildren returned to Olvera Street in 1981 for the dedication of the exhibit A Tribute to Christine Sterling. Today thousands of visitors pass through the exhibit located in the Avila Adobe annex. (Courtesy El Pueblo Historical Monument.)

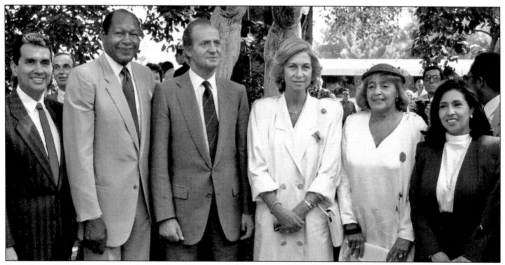

Los Angeles City Council member Richard Alatorre, Mayor Tom Bradley, King Juan Carlos I of Spain, Queen Sofia, Ethel Bradley, and California assembly member Gloria Molina pose for the camera during the 1987 dedication of the statue of King Carlos III. Today visitors to the statue learn that it was by the order of this monarch that the pueblo of Los Angeles was founded under the Spanish flag on September 4, 1781. (Courtesy El Pueblo Historical Monument.)

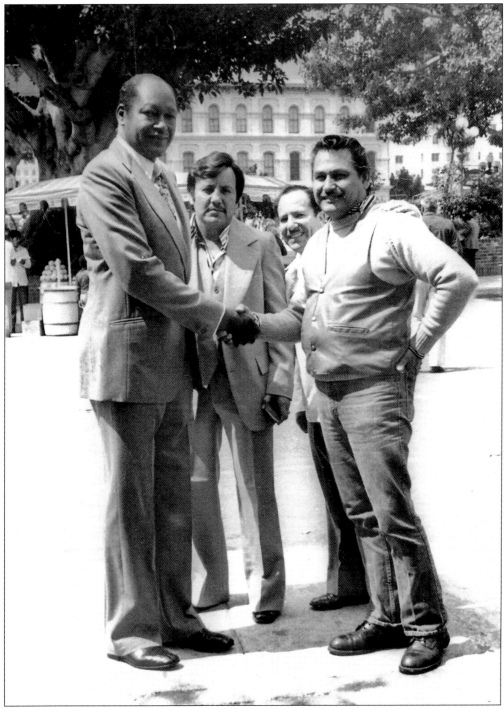

In the 1980s, Mayor Tom Bradley, the city's first African American mayor, is welcomed to Olvera Street by Fidel Velarde of Velarde's Fruits (center, right) and Manuel Murillo of Manuel Murillo Leather Goods (far right). (Courtesy El Pueblo Historical Monument.)

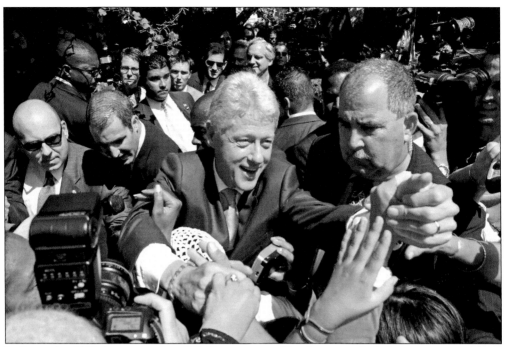

In September 2003, former president Bill Clinton, greeted by a large crowd of admirers, came to Olvera Street during the celebration of Mexico's Independence Day. (Photograph by Ezekiel Tarango.)

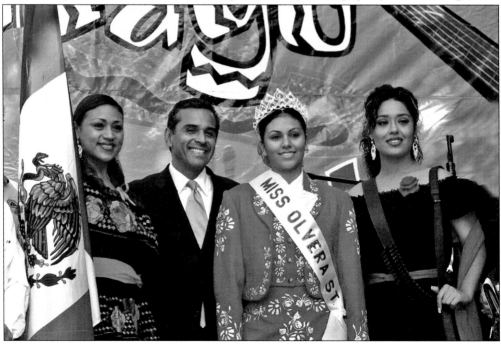

Elected in 2005, Los Angeles mayor Antonio Villaraigosa, the first Mexican American mayor of the city since the 19th century, sold newspapers as a boy around the plaza and Olvera Street. In this photograph, he is joined by Miss Olvera Street and her court at the annual Cinco de Mayo celebration. (Photograph by Ezekiel Tarango.)

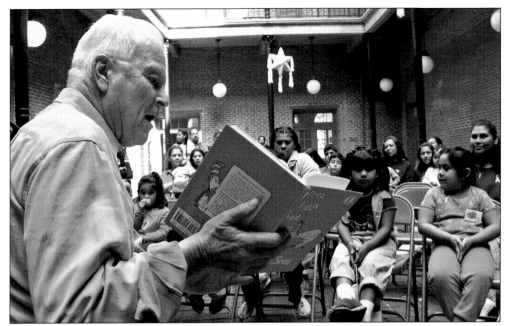

Throughout his long career as a businessman, politician, and philanthropist, Los Angeles mayor Richard J. Riordan (1993–2001) has been a tireless advocate for children's literacy programs. Today the Riordan Foundation works to ensure that all children become successful readers and writers by the end of second grade. In this photograph, the former mayor reads Dr. Seuss's *Green Eggs and Ham* to children in the courtyard of the Pico House. No doubt, Governor Pico would have been proud to see his beautiful courtyard being used to inspire the future leaders of Los Angeles. (Photograph by Ezekiel Tarango.)

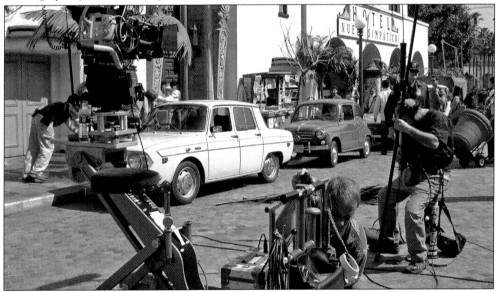

Since the days of Charlie Chaplin, Mary Pickford, and Buster Keaton, Olvera Street has been a favorite film location for Hollywood movies. Today the old plaza and Olvera Street is a favorite location for blockbuster movies, documentaries, and television commercials. (Photograph by Frank Damon.)

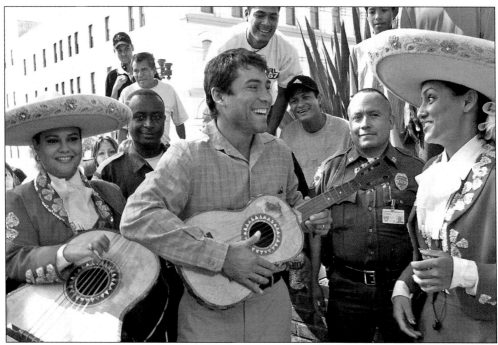

The son of Mexican immigrants, professional boxing champion Oscar De La Hoya grew up just a few blocks from Olvera Street. On this occasion he demonstrated his talent outside the boxing ring by singing a traditional Mexican ballad to his fans, songs which are now available on CD. (Photograph by Ezekiel Tarango.)

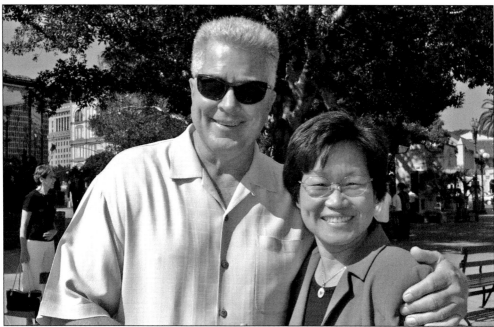

Huell Houser is among the most familar faces on public television, and Olvera Street is a favorite location for his popular shows on California history. In this photograph, he poses for the camera with El Pueblo curator/historian Suellen Cheng. (Photograph by Ezekiel Tarango.)

Five

OLVERA STREET TODAY AND TOMORROW

The 1960s continued to see the transformation of Los Angeles that began after World War II. New freeways and an explosion in suburban housing, shopping centers, and amusement parks meant that people began to spend less time in downtown for business and recreation. Even so, Olvera Street continued to hold deep sentiment for Angelenos who had long since moved away from the old neighborhoods in downtown. This was particularly true for Mexican Americans, who by 1960, had become the city's largest minority group—a fact noted by John F. Kennedy, who came to Olvera Street to seek Mexican American support in his campaign to become president.

After Sterling's death in 1963, Olvera Street's management structure also changed during this period. On December 1, 1965, a new joint powers agreement was signed, which established an 11-member commission to preside over El Pueblo, with five members appointed by the governor and three each by the county board of supervisors and the mayor of Los Angeles. The operation of the Olvera Street marketplace continued to be contracted out to El Pueblo de Los Angeles Corporation.

The late 1960s and 1970s was a tumultuous period for Los Angeles and the nation. The Vietnam War, a new period of immigration, and a changing world economy affected all sectors of the population. The 1970s and 1980s saw the transformation of greater Los Angeles as a result of large-scale immigration from Mexico, Central America, and Asia. Many of these immigrants established businesses in the city and played an important role in the revival of downtown. For Latinos, who were becoming the majority population, the plaza and Olvera Street area, now known as El Pueblo de Los Angeles Historical Monument, grew in its significance as an important historic and cultural symbol, as well as a vital area of recreation and religious life.

Changes in the management of the plaza and Olvera Street also occurred during this time. In 1972, the joint powers agreement and the contract were revoked. A new agreement was signed on April 1, 1974, whereby the City of Los Angeles, through its Recreation and Parks Department would operate the park. This arrangement lasted until the state legislature decided to turn the park over to the City of Los Angeles and voted to approve Senate Bill 53 on September 29, 1987. Under this legislation, the turnover was to be accomplished on or before January 1, 1989, and the park was to be governed under the guidelines outlined in its 1981 General Plan for El Pueblo. On February 12, 1990, the Recreation and Parks Department officially accepted ownership of El Pueblo de Los Angeles Historic Park.

After much discussion, however, it was decided that El Pueblo Park would fare better as a separate city department, outside the oversight of Recreation and Parks. Mayor Tom Bradley

appointed a new El Pueblo commission, but members were not installed as the timing was close to a citywide election. Richard J. Riordan was elected mayor in 1993 and proceeded to appoint a new commission, which was renamed El Pueblo de Los Angeles Historical Monument Authority Commission. The first meeting of the new commission took place on August 30, 1994. In compliance with the ordinance instituting El Pueblo as a new city department, a Merchant's Advisory Committee also was formed, with five persons elected to address the various issues that affect business and tourism on Olvera Street.

Today as the street commemorates its 75th anniversary, the new commission and advisory committee meet on a regular basis to address the critical issues that affect Olvera Street and the larger monument. Together—with many city employees, volunteers, merchant families, and support groups who comprise the El Pueblo family—they are carrying forward Christine Sterling's vision as they chart the future for the birthplace of Los Angeles.

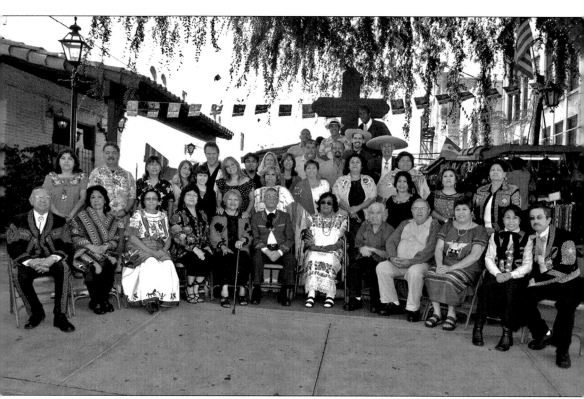

In 2005, Olvera Street merchants pose for a group shot. Many are the children, grandchildren and great-grandchildren of the original merchants who founded the street in 1930 with Christine Sterling. (Photograph by Ezekiel Tarango.)

For many years, visitors to Olvera Street have been delighted by the beautiful creations of glass artist Louis G. Diaz and his son Albert. This unique art form certainly amazes visitors of all ages. (Courtesy El Pueblo Historical Monument.)

In 2004, an Olvera Street *puesto* appears to be bursting at the seams with Mexican, toys, hats, and leather goods. (Photograph by Frank Damon.)

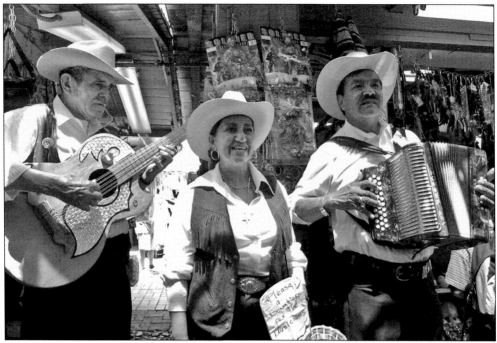

On any given day, the music of Mexico can be heard on Olvera Street, adding a special flavor to the delicious food that visitors enjoy at many of the street's patio style restaurants. (Photograph by Ezekiel Tarango.)

Olvera Street in the early morning is a special place to have a quiet cup of hot Mexican chocolate and to reflect on rich history of the birthplace of Los Angeles. (Photograph by Ezekiel Tarango.)

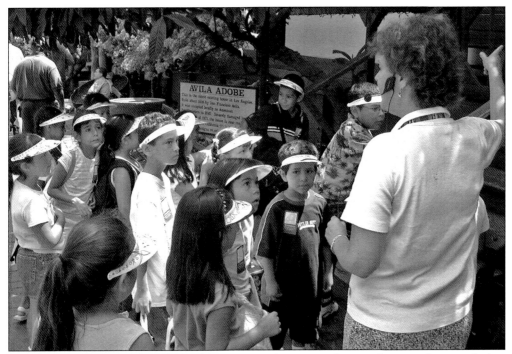

Marilyn Lee of Las Angelitas del Pueblo is among the many volunteer docents who provide free educational tours of El Pueblo. A retired downtown attorney, who for many years was in the middle of heated legal battles in the courthouse just one block away, Marilyn fell in love with the history and people of the old plaza and Olvera Street. Today she shares that love during her special tours for visitors, especially for local school children. (Photograph by Frank Damon.)

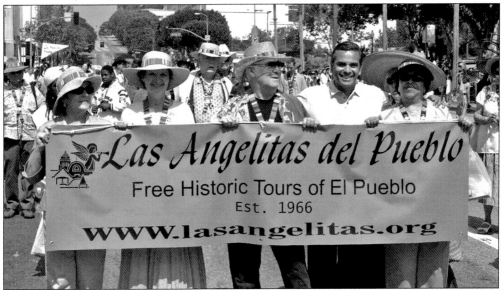

In 2005, Mayor Villaraigosa joins Las Angelitas del Pueblo in celebrating Olvera Street's 75th anniversary. The event was marked by a parade and a formal ceremony recognizing the contributions by Christine Sterling and the Olvera Street merchants in preserving the birthplace of Los Angeles. (Photograph by Frank Damon.)

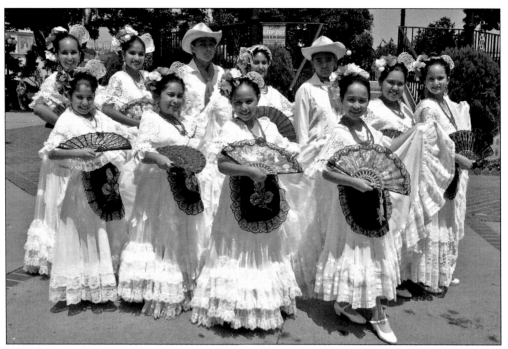
On Olvera Street, young dancers, dressed in beautiful white lace, carry on the traditions of Vera Cruz, Mexico. (Photograph by Ezekiel Tarango.)

Every year thousands of people come to the plaza to take part in Cinco de Mayo (5th of May) celebrations. Often confused with the 16th of September—Mexican independence day from Spain—Cinco de Mayo commemorates the Mexican victory over French occupation at the Battle of Puebla on May 5, 1862. (Photograph by Frank Damon.)

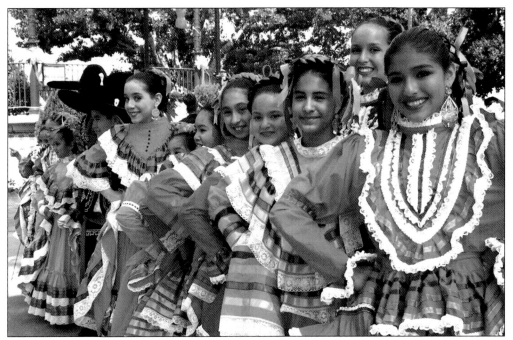
Young Mexican *folklorico* dancers at the plaza pose for the camera. (Photograph by Ezekiel Tarango.)

Since the days of Christine Sterling and Consuelo de Bonzo, Mardi Gras has been a favorite yearly event on Olvera Street. (Photograph by Ezekiel Tarango.)

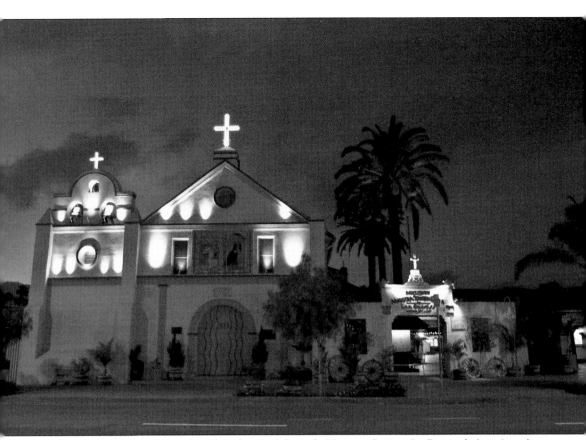
Our Lady Queen of Angeles Church—La Iglesia de Nuestra Señora La Reina de Los Angeles—watches over while the old plaza and Olvera Street sleep. (Photograph by Ezekiel Tarango.)

The statue of Gov. Felipe de Neve (1727–1784), founder of Los Angeles, is located on the west end of the plaza. Neve was New Spain's governor of the Californias from 1775 to 1783. In 1777, while en route to the territorial capital of Monterey, Neve passed through the Los Angeles basin and found it to be a promising site to establish a civilian pueblo. The pueblo would be a farming community that would support the missions and military presidios. Neve organized the expedition from northwest Mexico that brouth the 44 *pobladores* that founded El Pueblo de La Reina de Los Angeles on September 4, 1781. (Photograph by Ezekiel Tarango.)

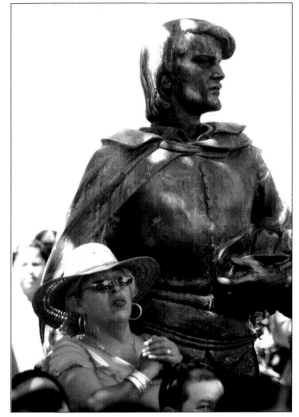

Visitors are making a wish at the Olvera Street fountain. (Photograph by Ezekiel Tarango.)

While shopping along Olvera Street, visitors can enjoy a great Mexican meal at El Paseo Inn. The restaurant is located in the old Winery building (1870–1914), which dates back to the 19th century when Olvera Street was the wine-making capital of Southern California. (Photograph by Ezekiel Tarango.)

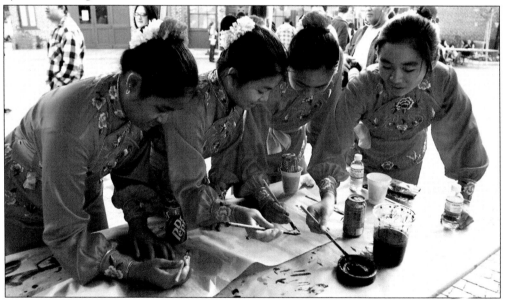

The Chinese Lantern Festival is a yearly event at the plaza (pictured here in 2004). Unlike the Western New Year's Day, the celebration of Chinese New Year consists of 15 days of festivities, which begin on the first new moon of the lunar calendar. On the Chinese New Year's Eve, families clean their ancestral tombs and burial grounds to respectfully invite their ancestors back home for the holidays. Signaling the close of the new year celebration, the Lantern Festival occurs on the first full moon. The lanterns represent the completion of this period of harmony and "roundness" because they lead the way home for the festival guests and their ancestors. (Photograph by Ezekiel Tarango.)

The day of lanterns sends the blessing of harmony, order, and unity to remain with everyone for the rest of the year. Like the glowing orbs of the lantern festival, the eating of rice dumplings called "tang yuan," a glutinous rice ball with a sweet filling, also symbolizes the wish that life runs sweetly and smoothly. In this 2004 photograph, a Chinese dragon winds its way through Olvera Street during the Lantern Festival. (Photograph by Ezekiel Tarango.)

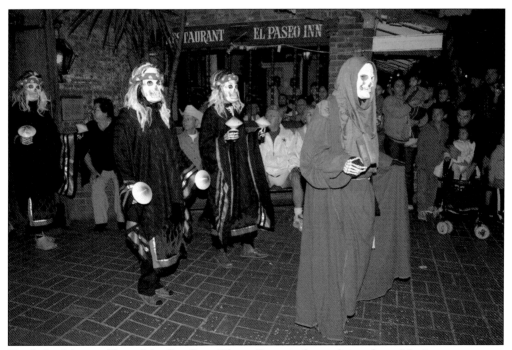

Dia de Los Muertos (Day of the Dead) on Olvera Street is the traditional way Mexicans reconnect with loved ones who have passed away. (Photograph by Ezekiel Tarango.)

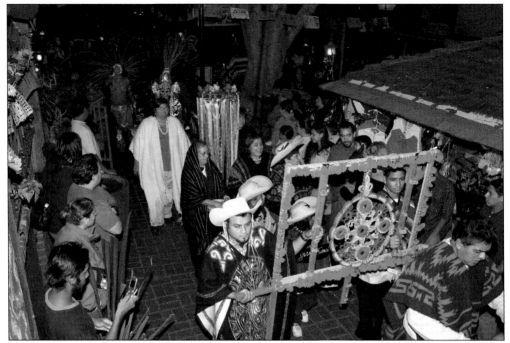

Olvera Street merchants Norma Garcia, Rosa Flores, and Diana Robertson (in white) lead the procession for the 2004 *Dia de Los Muertos*. (Photograph by Ezekiel Tarango.)

A difficult decision to make on Olvera Street is whether to buy an accordion or a guitar? Most merchants would recommend, "Why not buy both?" (Photograph by Frank Damon.)

Here is a typical Olvera Street wooden *puesto*. The first *puestos* began construction in the mid-1930s and their look has not changed over the years. (Photograph by Frank Damon.)

Colorful Aztec dancers, with drums pounding and sea shells rattling, are a delight to visitors at the plaza. (Photograph by Ezekiel Tarango.)

With one click of the camera, talented photographer Ezekiel Tarango has captured the beauty of Mexican dance and culture on Olvera Street. (Photograph by Ezekiel Tarango.)

Olvera Street merchant Guillermo "Memo" Garcia, owner of the always busy La Noche Buena at E-8 Olvera Street, prepares his delicious tacos. (Photograph by Ezekiel Tarango.)

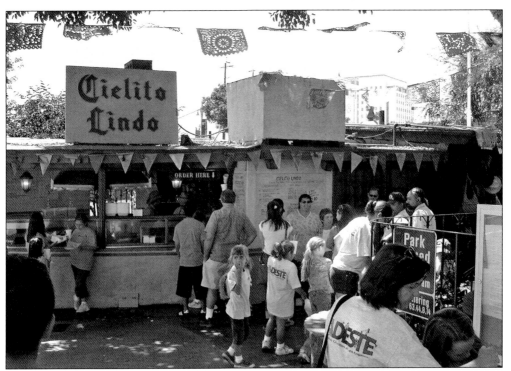

A regular stop for visitors to Olvera Street is Celito Lindo to sample their famous taquitos. (Photograph by Frank Damon.)

Blessing of the Animals has been organized by Olvera Street merchants since the 1930s and no animal is too large or too small for the yearly blessing of Card. Roger Mahoney. (Photograph by Frank Damon.)

Valerie Garcia Hanley (center) is the daughter of Mike and Norma Garcia of Casa California. She is now a third-generation Olvera Street merchant and has taken part in the Blessing of the Animals since she was a child. (Photograph by Frank Damon.)

All blessed and ready for another year of Chihuahua mischief! (Photograph by Frank Damon.)

The *Blessing of the Animals* mural by renowned Italian American artist Leo Politi (1910–1996) is a favorite among children and can be found in front of the Biscailuz Building. Politi began painting his now famous images in the 1940s, many of which became popular children's books. Today he is regarded as the artist of Olvera Street. (Photograph by Frank Damon.)

El Pueblo museum guide Elmo Gambarrana, a native of New York, takes notes at the end of another busy day at the Old Firehouse, where his talks fascinate visitors. (Photograph by Ezekiel Tarango.)

Mike and Rosa Mariscal lead the solemn procession on Olvera Street during *Las Posadas*, held each year in December, while merchants Archie Santana, Manuel Murillo, and Rafael Caballero follow as the three wise men. (Courtesy El Pueblo Historical Monument.)

Italian Hall was constructed in 1907–1908 by a French woman, Marie Ruellan Hammel, and is the future home of the Italian Hall Museum. (Courtesy El Pueblo Historical Monument.)

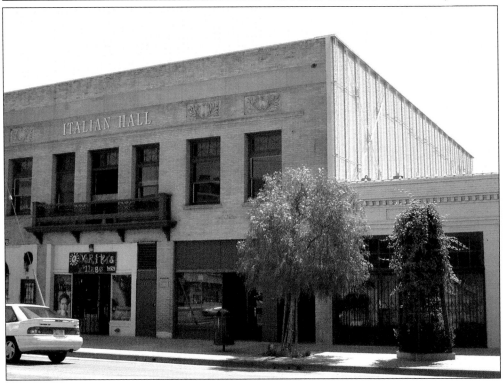

In 2005, members of the Historic Italian Hall Foundation march in commemoration of the 75th anniversary of the opening of Olvera Street. (Photograph by Ezekiel Tarango.)

El Pueblo museum guides Olivia de la Riva and Pat Lopez provide visitors with fascinating tours of the Avila Adobe Museum on Olvera Street. (Photograph by Frank Damon.)

An interior view of the Avila Adobe dining room shows how it may have appeared in the 1840s. The Avilas were a prosperous ranching family of the Mexican era in Los Angeles and were the owners of the nearby Rancho La Cienega. Their 1818 adobe on Olvera Street is the oldest existing house in Los Angeles. (Photograph by Ezekiel Tarango.)

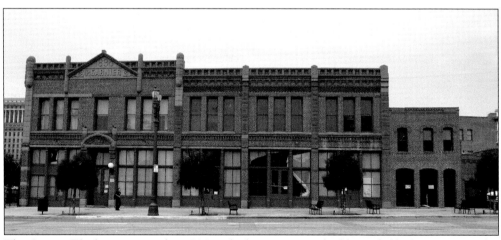

The Garnier Block, constructed in 1890, is the last remaining building of old Chinatown. Today it is home to the Chinese American Museum. (Photograph by Ezekiel Tarango.)

In December 2003, the Chinese American Museum opened. (Photograph by Frank Damon.)

The founders' plaque is where all tours begin. Listed on the plaque are the names of the original 44 *pobladores* (founders) of Los Angeles. They consisted of 11 families, with 22 adults and 22 children, and were of Native American, African, and European heritage. Today many of their descendants march from San Gabriel Mission to the plaza on September 4 to commemorate the founding of the city. (Photograph by Ezekiel Tarango.)

A replica of the Bell of Dolores, the symbol of the Mexican fight for independence from Spain (1810–1821), is pictured here. (Photograph by Frank Damon.)

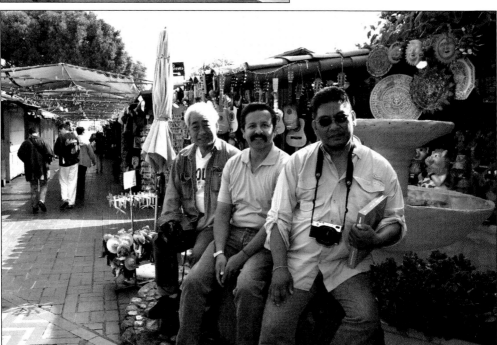

Olvera Street is a treasure trove of photographic opportunities. Pictured here are Olvera Street's professional photographers Kaz Majima (left), Ezekiel Tarango, and Larry Abellera.

At busy Juanita's on Olvera Street, owned by the Guerrero and Flores families, it is always service with a smile. (Photograph by Frank Damon.)

Bells in front of the old Avila Adobe take one back in time, when horses and buggies rode down Olvera Street. (Photograph by Frank Damon.)

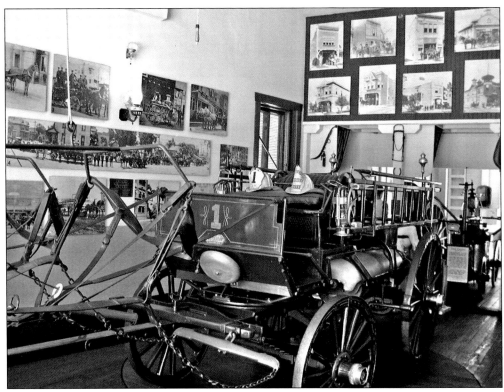
Inside the Old Plaza Firehouse, established in 1884, are treasures from the early days of Firehouse No. 1. (Photograph by Frank Damon.)

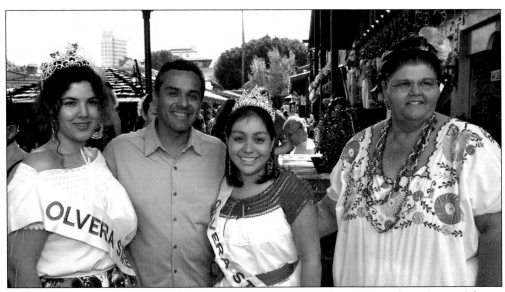
Adriana Aguirre-Robles (Miss Olvera Street 2003), Los Angeles city coucilmember and future mayor Antonio Villaraigosa, Christina Mariscal (Miss Olvera Street 2001), and Olvera Street merchant Diana Robertson pose for this 2004 picture in front of Robertson's popular Las Anita's Cafe, located at W-26 Olvera Street. (Photograph by Ezekiel Tarango.)

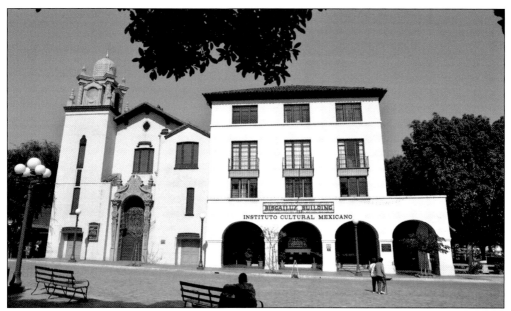

Constructed in 1926 at the site where the adobe of Judge Agustín Olvera once stood, the Plaza Methodist Church and Biscailuz Building are the "newest" buildings at El Pueblo. The gallery and exhibits of the Mexican Cultural Institute and the administrative offices of El Pueblo de Los Angeles Historical Monument can be found inside. (Photograph by Ezekiel Tarango.)

The flags of Mexico and the United States convey to visitors the rich history of Olvera Street and the City of Los Angeles. (Photograph by Frank Damon.)

Traditional Mexican toys have long been a favorite item on Olvera Street. (Photograph by Frank Damon.)

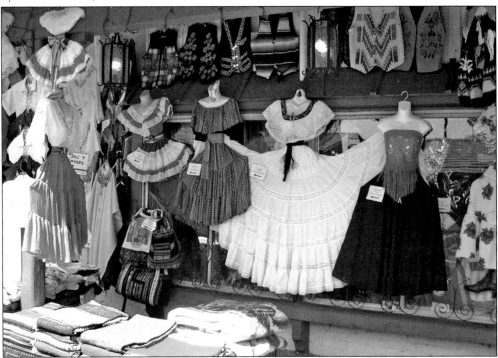
Beautiful Mexican dresses, purses, and serapes are always available on Olvera Street at bargain prices. (Photograph by Frank Damon.)

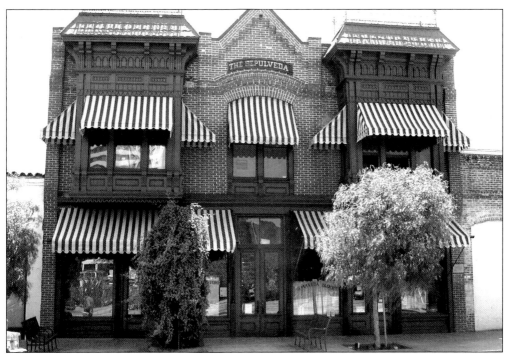
The Sepúlveda House, built in 1887, is a popular house museum and home to the El Pueblo Visitors Center. (Photograph by Frank Damon.)

Pictured, from left to right, the Pico House (1870), Merced Theatre (1870), and Masonic Hall (1858) are among the architectural treasures at El Pueblo de Los Angeles Historical Monument. Along with four other buildings at El Pueblo, they are listed on the National Registrar of Historic Places. (Courtesy El Pueblo Historical Monument.)

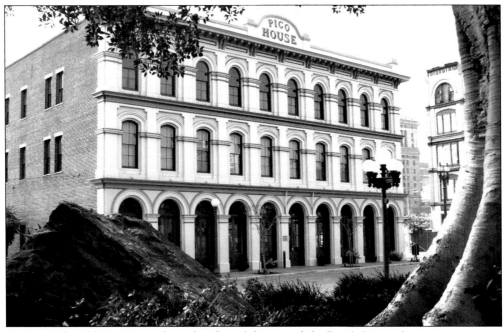

A view of the old Pico House from the plaza. (Photograph by Frank Damon.)

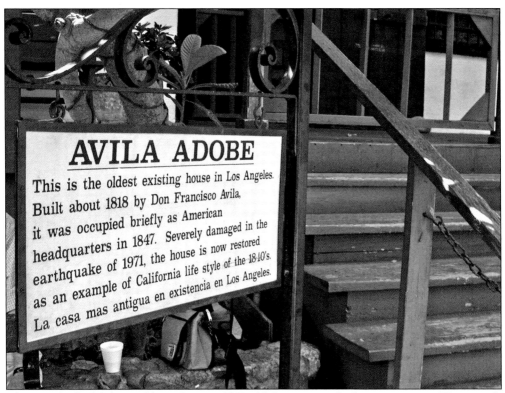

The 1818 Avila Adobe on Olvera Street is El Pueblo's most popular house museum. (Photograph by Frank Damon.)

A Mexican *carreta* is in the courtyard of the Avila Adobe. (Photograph by Ezekiel Tarango.)

This statue of King Carlos III of Spain in the plaza was dedicated in 1987 by King Juan Carlos I and Queen Sofia of Spain. Visitors to El Pueblo Historical Monument, especially schoolchildren, learn that the City of Los Angeles has been ruled by three nations: Colonial Spain (1781–1821), Mexico (1821–1848), and the United States (1848–present.) (Photograph by Ezekiel Tarango.)

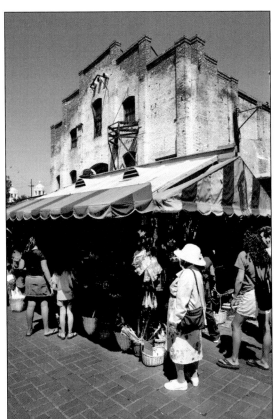

While shoppers browse on Olvera Street, the old Plaza Substation, built in 1903 for Henry Huntington's Pacific Electric Railway cars, watches over. The Plaza Substation will be home to a future museum of transportation. (Photograph by Ezekiel Tarango.)

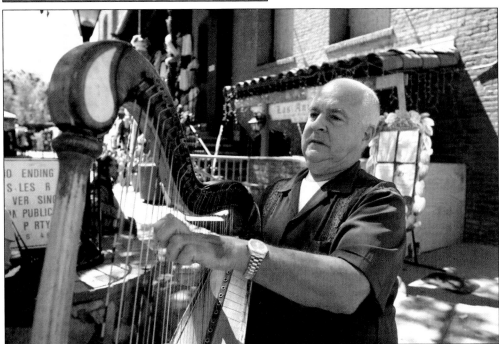

A Mexican harpist plays in 2005 on Olvera Street. (Photograph by Ezekiel Tarango.)

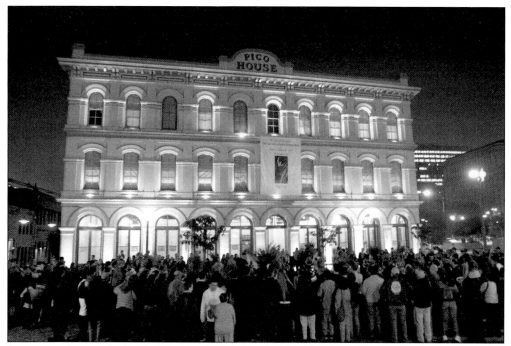

In a scene that no doubt also occurred in the 19th century, the Pico House, at night, plays host to a Los Angeles social event. (Photograph by Ezekiel Tarango.)

The statue of King Carlos III looks toward the *kiosko* in the plaza. (Photograph by Ezekiel Tarango.)

Traditional Mexican candy, sold by Olvera Street merchant Rosendo Quezada, is a favorite among children. (Photograph by Frank Damon.)

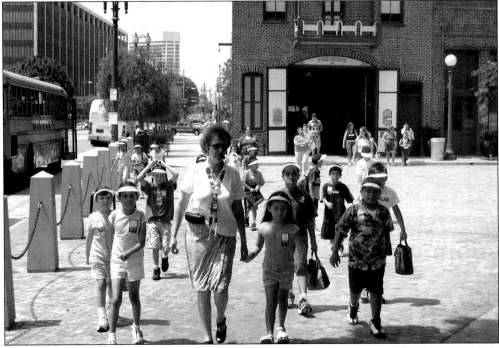
Educational tours for schoolchildren are conducted by Las Angelitas del Pueblo (the Little Angels of the Pueblo) and lots of fun is guaranteed, especially when Marilyn Lee is your guide. (Photograph by Frank Damon.)

La Golondrina Cafe, located in the old Pelanconi House (1855)—the oldest brick building in the city—is a favorite place for great Mexican food. And don't forget their famous margaritas! (Photograph by Frank Damon.)

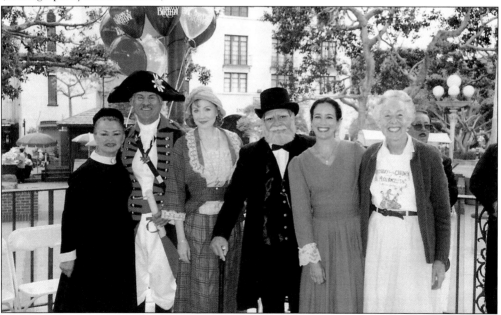

The founding of Los Angeles on September 4, 1781, is celebrated every year by the city. Among the highlights of the event is a reenactment of the historic walk from San Gabriel Mission to the plaza by the 44 *pobladores* (founders). Professional actors, from left to right, portray important figures in El Pueblo's early history: Eloisa Martinez de Sepúlveda, Gov. Felipe de Neve, Christine Sterling, Gov. Pío Pico, and Encarnación Sepúlveda de Avila. They are joined by El Pueblo's senior curator emeritus, Jean Bruce Poole, at far right. (Courtesy El Pueblo Historical Monument.)

Las Angelitas del Pueblo was established in 1966 and provides free educational tours to over 14,000 people each year. It consists of people who have a deep interest in the history of Los Angeles and a desire to share that history with the larger community. Because of their dedication to local history, in 2004 the docent organization was awarded the first Save Our History Preservation Award by the History Channel. In this photograph, the board of directors of Las Angelitas del Pueblo pose for the camera in the Avila Adobe courtyard. Pictured, from left to right, are Bob Aguirre, Marlene Gordon Pfeiffer, Elizabeth Rojas-Maya, Mary Louise Uranga, Marilyn R. Lee, Don Sloper, Barbara Fisher, Anne Ingram, Jeanne Conklin, Alicia Brown, and Frank Damon. (Courtesy Frank Damon.)

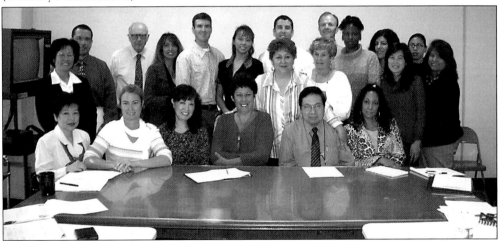

As a department of the City of Los Angeles, the 44-acre El Pueblo de Los Angeles Historical Monument, which includes Olvera Street, is run by a talented staff who manage all aspects of historic preservation, tourism, parking, finances, traditional events, public relations, and long-range planning for the birthplace of the city. The staff, pictured, from left to right, are (first row) Kanda Law, Julie Sandoval, Sharon Chow, Caroline Asencio, Leo Limqueco, and Angelique Smith; (second row) Suellen Cheng, Hector Morales, Steve O'Hare, Gloria Giangiuli, John Kopczynski, Jeannie Kepler, Linda Duran, El Pueblo general manager Rushmore D. Cervantes, Marlene Mall, John Forland, Sharon Douglas, Mariann Gatto, Loanne Truong, Jessica Herrera, and Cynthia Vallejo. (Courtesy El Pueblo Historical Monument.)

This Olvera Street brochure from the 1980s says it all. (Courtesy El Pueblo Historical Monument.)

The popcorn wagon and La Luz Del Dia Mexican restaurant are popular places to satisfy any appetite. (Photograph by Frank Damon.)

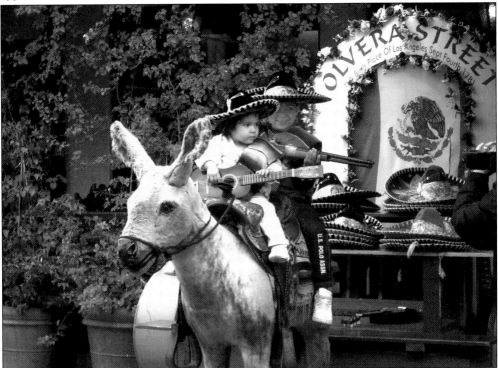
A trip to Olvera Street is incomplete without a souvenir photograph on "Jorge," the famous stuffed burro. (Photograph by Frank Damon.)

In the faces of its children, photographer Ezekiel Tarango has captured the hopes, dreams, and beauty of the Olvera Street Mexican marketplace.

Olvera Street, or *Calle Olvera*, is the birthplace of Los Angeles. (Photograph by Ezekiel Tarango.)

BIBLIOGRAPHY

Bruce Poole, Jean, and Tevvy Ball. *El Pueblo: The Historic Heart of Los Angeles*. Los Angeles: The Getty Conservation Institute and the J. Paul Getty Museum, 2002.

Estrada, William D. "Los Angeles's Old Plaza and Olvera Street: Imagined and Contested Space." *Western Folklore*, 58 (2), California Folklore Society, 1999.

Kelsey, Harry. "A New Look at the Founding of Los Angeles." *California Historical Quarterly*, Winter 1976.

Kroop, Pheobe S. "Citizens of the Past? Olvera Street and the Construction of Race and Memory in 1930s Los Angeles." *Radical History Review* (81) 2001: 35–60.

Lothrop, Gloria Ricci. "Italians of Los Angeles." *Southern California Quarterly*, 85 (3), Fall 2003.

Robinson, William Wilcox. *Los Angeles from the Days of the Pueblo: A Brief History and Guide to the Plaza Area*. San Francisco: California Historical Society, 1981.

See, Lisa. *On Gold Mountain: The One-Hundred-Year Odyssey of a Chinese-American Family*. New York: St. Martin's Press, 1995.

Sterling, Christine. *Olvera Street: Its History and Restoration*. Long Beach, California: June Sterling Park, 1947.